S0-AHC-824

JOURNEY TO THE JUNGLE

An Artist in Peru

CORINNA SARGOOD

BLOOMSBURY

First published in Great Britain in 1988 by
Bloomsbury Publishing Ltd, 2 Soho Square, London W1V 5DE
Copyright © 1988 by Corinna Sargood

ISBN 0-7475-0280-3

Photoset by Rowland Phototypesetting Ltd
Bury St Edmunds, Suffolk
Printed in Great Britain by
Butler and Tanner Ltd, Frome and London

For
Henry and Rosie

CONTENTS

ACKNOWLEDGEMENTS

As a peripatetic etcher with a sharp eye for an unoccupied press, I am very grateful to Stanislav Blatton and the Working Men's College; also to Istvan Gettler at the Architectural Association.

I would like to thank Tom Barrett for laboriously dissecting a huge sheet of copper, rendering it an almost harmless piece of luggage. My thanks also go to John King, who turned up one winter's day with a tiny etching press; and to Oliver and Mary Turner, for mooring my home next to the potting-shed where I could work when the Regent's Canal, full of cranes and pile-driving plant, became too turbulent.

I am indebted to Fuji Film UK Ltd, for their generous gift of film to take to Peru; and to William Jones, for inspiring me with his enthusiasm for South American plants.

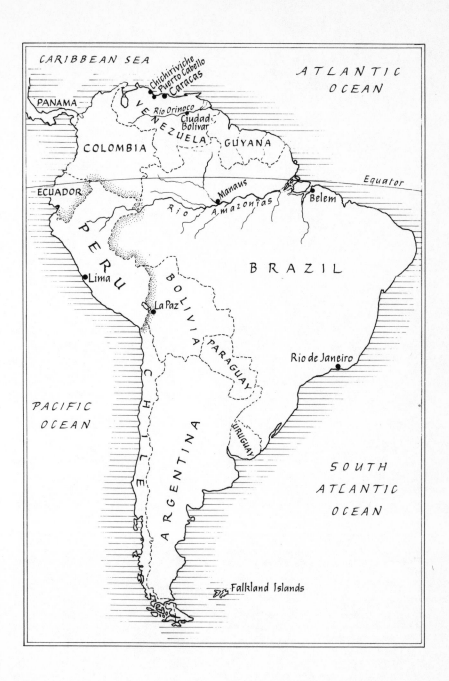

CARIBBEAN SEA

ATLANTIC OCEAN

PANAMA

Chichiriviche
Puerto Cabello
Caracas

Rio Orinoco

V E N E Z U E L A

Ciudad
Bolivar

COLOMBIA

GUYANA

ECUADOR

Equator

Manaus

Rio Amazonias

Belem

P E R U

B R A Z I L

Lima

La Paz

B O L I V I A

PARAGUAY

Rio de Janeiro

PACIFIC OCEAN

C H I L E

A R G E N T I N A

URUGUAY

SOUTH ATLANTIC OCEAN

Falkland Islands

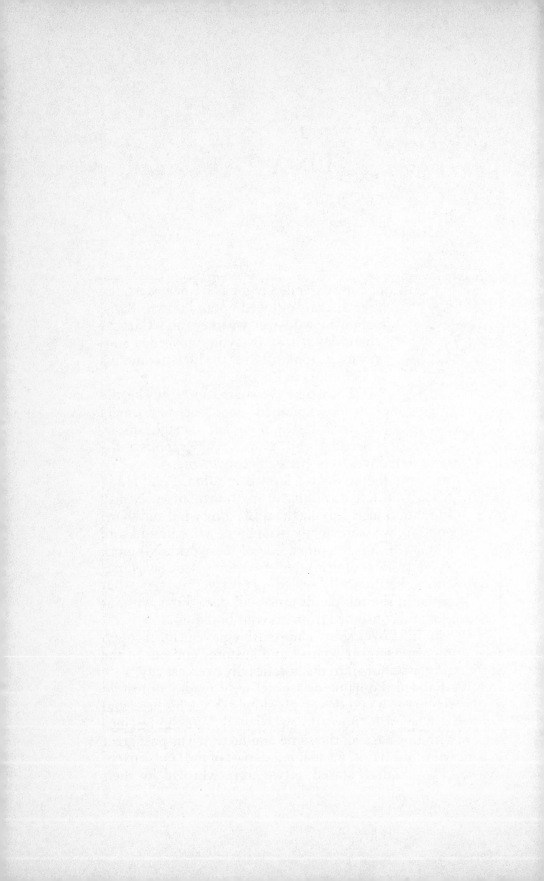

I

LIMA

ll through the extended night as we flew west, the huge aircraft plunged up and down: Paris, Lisbon in wild wet weather, and Caracas where dawn rose over the unweeded runway as we took off over the high mountains of Colombia to Bogotá.

Each time we soared into the sky the safety instructions were explained until the performers appeared like mime artists, sleight of hand magicians or ventriloquists, only needing white gloves, white rabbits and a flock of coloured doves to be perfectly convincing.

By the time the aeroplane landed in Lima, I had really begun to wish I'd left travelling to my imagination. Nearly twenty-four hours after leaving the cold biting wind and sharp rain of London, we were finally brought down, stiff and sore from confinement, on the other side of the world. No more trays of food, trolleys of drinks, transparent plastic envelopes of earphones, hermetically sealed against germs, films that had flickered in the middle distance, all dished out without enthusiasm and consumed from nervous boredom.

We shuffled over shiny chip-marble pavement, through the oppressive passport control and customs and out of the automatic glass doors into the hot, heavily overcast city.

We handed the name of a hotel we'd read about in an outdated book to a taxi driver. He slowly shook his head and answered in Spanish, 'Burnt down last week.' We climbed into his car with our bags all the same and he drove us past great hillsides of rubbish tips, all an integral part of the landscape of shacks. The children stared as we were whisked by their

1

homes of untidily laminated cardboard boxes and bits of scrapped car. Eventually the taxi dropped us at a central lodging house.

And into the sleep of a terrified dog, black and deep. Eighteen hours later I unwillingly allowed myself to wake and lay trying to invent a plausible story to cover an immediate return to the chilly damp of an English November. The room smelt dank; I felt sick. On the pale green walls hung sepia photographs of good-looking men and women with the seriously composed fixed expressions of the long exposure, and faded views of the countryside in times past.

The French doors opened onto a passage, white cotton curtains covered the glass, gathered firmly onto elastic top and bottom, allowing only a grubby light to filter through into the room. Clutching my sponge bag, I stepped out along the unknown labyrinth of passages to find a lavatory.

Every corner, every bend, every place where the passages widened and could accommodate more than the width of a broad bottom was constricted by tables, sideboards, shelves, credenzas, all laden with ornaments arranged in tiers on layers of cloth or plastic doilies. The bulk of them had a religious and whimsical flavour: portraits of Our Lady simpering with glitter and pallid cheeks; Our Lord behind tiny filigree doors of luminous plastic; portraits of saints in pairs. Reconstituted marble crucifixes in all sizes were nailed to the walls. More Christs were propped up against more bas-relief saints who, in turn, leaned against larger items. Plastic lilies and chrysan-themums and paper roses sprang from vases of flecked glass blown into sensual labiate shapes.

I felt as if we'd discovered the supplier to all the trinket stalls on Naples railway station.

The marble-tiled bathroom, with old-fashioned monu-mental furniture, fixtures and fittings, was through the kitchen, up or down various corridors, between numerous rooms. I leaned against the generous basin. From the brass tap a short brown length of water spluttered out. Hardly wetting the toothpaste, I lightly drew the brush across my front teeth. Looking up, I caught the shaded reflection of my grey, tense

2

face in the speckled mirror. I felt cheered to recognize something familiar, even though the image hardly inspired confidence. It reminded me of my mother.

Squeezing ourselves into the dark upright dining-room chairs jammed between the sideboards groaning with knick-knacks and the heavy lace-clothed table, we sat and ate breakfast.

Stags at bay in purple landscapes and succulently lipped ladies in golden encrusted frames tipped out at alarming angles from the picture rail above us. The overriding sounds in the quiet, gloomy dining room were the clink of knives on plates, spoons over-stirring tea and short rushes of hot water from the flasks as we experimented with the brown syrup we were assured was coffee.

We half smiled at the other guests and spoke to each other distinctly under our breaths. Maybe the proprietress asked if all was well, but she backed away politely when her Spanish only confused us.

Finally, when we alone sat among the dishevelled remains of the meal, nervously picking at a plastic flower, there was nothing left but to stand up, ease ourselves out from the table and go out.

It was warm outside but dismally overcast with an even layer of grey cloud. We walked towards the centre of Lima, slowly picking our way through the streets, up past the old colonial buildings that lined each side with ranks of ornately carved wooden balconies that protruded well over the pavements.

In the Plaza de Armas we passed the presidential palace where Pizarro had lived before his assassination in 1541. Its modern façade was now guarded by bored looking soldiers suffering in sixteenth-century military costume – knickerbockers, hose, and doublet tight under the armpits.

Outside the cathedral, displayed for sale up the sweep of steps leading to the great dark closed doors, were candles,

blocks of grey incense, key rings and pens with girls whose clothes dropped off before your eyes when tipped vertical. These were piled among pictures of pouting ladies with cleavages that could be confused with buttocks, necklaces, and crosses (both empty and occupied). There were tangles of rosaries, shoelaces, India rubbers, Virgin Marys and martyrs, and lithographs of the dead and dying saints in poses fit for a dimly lit corner of a sex shop.

Along the arcade running by the main post office, hundreds of postcard stands revolved and squeaked as we looked at the pictures of mountains and llamas and peasants in vivid medieval costume. I picked out a card with a white church, its carved façade sparkling in the bright sunshine. Turning it over it read 'Arequipa. The Cathedral'. 'Let's go there,' said Rosie.

Eventually we went inside a tea shop, neither too gloomy nor too smart. Pointing at the menu chalked up on a large board behind the counter, we ordered tea and were served with a cup each, from which the string of a tea bag dangled, 'The Bristol Tea'. Later we were asked to describe the tea plantations on the hills of the English West Country.

The market was seething with people, the stalls barely visible under landslides of fruit and vegetables which spilled into the roadway. The pavements were knee deep with listless beggars, all tangled with the rubbish that overflowed the gutters. A man in a faded feather head-dress, tattered poncho, and the frayed uppers of what had been plimsolls tied round his ankles was standing by a large wooden barrel. Peering in, we saw he was selling iguanas and boa constrictors, dead and cleaned and stinking. Limp babies were tied in shawls on their mothers' backs, which they shared with the rest of the load: vegetables, fruit and herbs, faggots and animal dung.

We walked towards the bus station. The traffic police, each in a pair of smart polished boots, stood elevated on a wooden box. Each was topped with a smart white plastic pith helmet. Each was turned out in a smooth grey uniform looped with blancoed braids. They flayed their arms with energetic purpose and filled out their cheeks like pears as their shrill whistles blew the signals to stop and start waves of battered

vehicles, making sure of a speedy clear passage for the occasional sumptuous limousine.

The less frenetically occupied military police had the time to finger the triggers of their submachine guns and to fondle the white leather holsters of their pistols. They leaned with a menacing slump against walls or doorways as if waiting for more than the day to end, catching the eyes of girls in modern dress and winking. Outside an ice-cream parlour several leaned against their armoured car, curling their tongues round ice-cream cornets.

In the Parque Neptuno, couples kissed and fondled for hours, held back from the brink of dishonour by the eye of the public gaze. The prickly stone of the fountain with the old man of the sea attending mermaids, tridents and dolphins was dry and grey. A slow-moving gardener swept the rubbish into piles. The trees were in bud; it was spring. Seasonless, the palms towered over the park. Ragged families lived in the base of the trunks in the revolving shadow that kept them on the move all day when the grey clouds lifted.

Shoeshine boys with their boxes of bottles and brushes lined the perimeter fence of the municipal gardens, glanced and then left us alone in our cloth shoes.

We arrived back at the hotel to find confused shouting, its echoes bouncing off the walls along the stone corridors. At the eye of the panic, smoke billowed from the laundry room, outside which were piles of crumpled sheets. The proprietress stood wailing and wringing her hands.

The thought of being burned alive so far from home compelled me to grab a bundle of wet sheets and rush through the black smoke into the darkening room. Suffocating the fire with the sheets, I emerged from a cloud of steam into a bank of powerful embraces and exuberant kisses before we were led into the kitchen for large cups of pale tea.

On the way back to our room, we glanced into the blackened room. Dozens of great glass jars, lidless, were standing on the tiled floor, each filled with pink paraffin.

* * *

5

We went to the museum, filled with ancient pottery. Cupboards and shelves were crammed with figurative vessels. There were portraits of heroes, models of animals and other pots had their rounded surfaces covered with descriptive scenes. There were illustrations of devils and wild creatures, serpents, stags and swans, vampires and demons. I drifted through the rooms, peering into the glass cabinets at the confused myriad of pots on which the dark side of the Chiclin and Mochica culture was repeatedly illustrated.

In a separate room, reached through a small door under the trees of the museum garden, were pots which must have stood on the shelves of every noble home before the conquistadors arrived and life was encumbered by Christianity. They displayed fertility symbols now billed as erotic art, pulling in the crowds who enthusiastically peered into the various cabinets, trying to shake off their self-consciousness. The pots were classified by different sexual positions. Generally, the expressions on the faces of the hollow clay lovers were serious and often resigned. The cupboard of copulating animals had the more light-hearted quality of enjoyment.

That evening in the centre of Lima the traffic was stopped; the quietness was eerily punctuated by the banging of hammers which echoed round the colonial façades that was the perimeter of the main square. The finishing touches were being put to the speakers' platform and bunting was being tacked in swathes round the edge of the stage.

Lorry-loads of soldiers stood in forbidding clumps, bristling with guns of every type. The Plaza de Armas began to fill with people, and banners were held above the heads of the crowd. Swastikas hung limply in the breathless air. We left through the cobbled back streets, empty of cars, before the crowds even began to think of rushing home to beat the curfew.

Tomorrow we were due to leave by the one o'clock bus.

2

THE DESERT AND
THE NAZCA LINES

he landlady sat with us in her kitchen, brewing tea and boiling rice. The steam gathered and rose slowly in the windowless room where the 40-watt gloom was diffused by encrustations of fly dirt.

She was a large lady, her build most suitable for sitting down. While the tea brewed, she got up to water some of the hundreds of plants that filled every space not occupied by religious ornaments. Stooping slightly, she bent over every pot, and with watering-can spout prodded the soil around each base in an affectionate if interfering way. Mainly cacti and succulents, she began to explain how to prepare each as a remedy and what their particular properties were. She promised to give us an infusion of the star-shaped section of peyote cactus on our return – to cure eye trouble. Out from a cupboard she pulled a large plastic bag filled with crisp dried leaves; coca leaves, she explained, as I peered in at my first sight of the dried leaves that made the tea that had anaesthetized me these last few days.

We drank another cup together as we paid the bill and listened to the canary singing from its tiny cage high up on the wall.

Then on to the bus station and to Ica, leaving fawn-coloured Lima where the bricks and mortar buildings gave way to many miles of fawn-coloured shanty ribbon developments, wicker shacks, buried near the road in fawn dust.

7

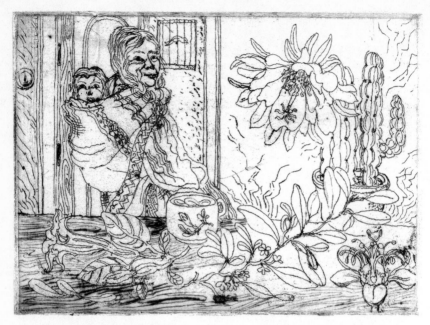

The landlady of the lodging-house with three of her medicinal plants: datura, coca and peyote

Clouds flew up as the Marco Polo bus sped by and settled eventually on the people, who were fawn-coloured too. It took a while to realize that the fawn-coloured landscape was now desert. Bare fawn mountains rose up until obscured by strangely pink fawn mist. On the other side, between the huge sand dunes, were triangular glimpses of the Pacific Ocean.

For five hours the bus roared south down the Pan-American Highway through a real Rudolph Valentino desert, a moonscape which, as the temperature soared, felt like the sun. Every now and again an oasis appeared, with palm trees, mud and bamboo dwellings strung haphazardly together with lines of washing dry and stiff in the burning heat. Occasionally the bus stopped at a village for company checks, where in a rush children would clamber on to sell fruit and nuts or sweet drinks or sing a song or be a clown to a mainly passive, sweaty, enervated audience. The captives mechanically put their

hands in their pockets for the few intis that would buy relative peace and quiet, but only until the next stop when a new band of ragged dust-caked vendors and showmen would clamber aboard.

Quotations from the Bible, grown in tough Tillandsia plants, adhered to roadside slopes. Their growing tips pointed towards the sea as they die off from the landward side. Wayside shrines with brittle dried flowers marked the sad spots of death at road level, while spindly iron crosses topped the domes of the nearby dunes. Catholicism was alive and well and kicking where it hurt most. It was as if we were seeing a part of the world flayed alive as we flew past the villages and saw the indigenous population with their copper skin and smooth faces watch us with listless dark eyes.

The bus tipped us out when it stopped briefly at the small colonial town of Ica. Here we found the Hostal Del Valle, a most beautiful old lodging house. Great carved doors like those that nightly close the rest of the world from an Italian *poggio* swung open during the day onto a courtyard overflowing with brilliant flowering bushes and shrubs which climbed up and over the walls. An aviary filled one side with isolated singing finches. Stacked up the wall, each cage was like a miniature fretwork railway station on the Somerset and Dorset line. Rooms led off the other two sides. All the walls were plain, distempered pink, pale green or cream. The plain stucco had been picked out in white and the wood preserved with a heavy coat of liver-coloured paint.

Only one shrine, a grotto and fountain with damp ferns and liverworts, surrounded the regulation Virgin Mary; she had recently been done up, painted with the left-over colours of her surroundings.

It was the first peaceful and quiet place we'd found and the first cloudless sky we'd seen in Peru.

On the outside of the huge window of our room were impenetrable wrought-iron scrolls, while inside were wooden shutters, divided like a stable door. These closed off the view of San Francisco across the street, but not the resonating sound of its quarterly chiming clock. Hardly any windows

were glazed in this desert town. From the beam and bamboo ceiling fifteen feet above us dangled the long, long flex of the guttering electric light bulb.

We wandered about in the Plaza de Armas where people were smiling pleasantly. The police were whiling away their evening duty quietly fondling themselves, their hands in their trouser pockets instead of fingering the triggers of their guns. They greeted us as we passed. When they learned we were mother and daughter, they didn't press their initial invitation to a night on the town.

In the main square, huge holm oaks overshadowed the buildings and the water in the modern fountain was clear, even if it was not flowing. We sat and watched the setting sun, salmon pink and orange on a turquoise background behind the white cathedral turrets and palm trees.

In the day the sky was a heavy blue and the heat at midday so fierce that it wasn't until teatime that we emerged from our dark room to visit the museum on the edge of the town. This was where the desert began again.

November is spring. All the trees were in flower, and there was no subtlety about the displays of flora. There were red-hot blasts from the hibiscus flower and papery bougain-villaeas. When red, they were really red; the same with yellow or blue or purple. All were vibrant saturated colours. Clank-ing brown pods hung from the branches of the municipal carob trees as they bloomed, growing up from square holes in the dusty pavements. Strawberries and pineapples, mangoes and avocado pears were all ripe.

Suddenly it was the end of the town and fawn dust billowed. A fawn stone-lined path led across a barren waste-land to the fawn buildings of the Regional Museum. Behind rose the bare mountains shimmering in the rising heat.

Inside the cool building, with its high ceilings and shining stone floors, it was quiet.

Mummified bodies in glass cabinets were folded as neatly as deck chairs. There were terrible grins on their tattered faces, which still adhered to their re-shaped skulls. Unwound from their beautiful, intricately woven shrouds, they sat crouched

10

among all the usual accessories of death and burial. The shrouds were displayed in another room, pinned flat to the walls. The finest had comic strips of dancing scenes and demons, of snakes and terror. There were fragments of cloth with llamas and fruits entwined with serpentine scrolls.

What at first glance looked like a worn bead curtain was the quipu, the ingenious memory pad of the Incas' unwritten language. In knotted string the Incas recorded numbers, composed music and, most mysteriously, laid down their laws. Behind the reflecting glass in the same room were beautiful pots from Nazca. There stood a kitten teapot with a sweet smile on its face and a canary under its front paw.

That evening I felt tired. In the fading daylight, our room with its yellowing distempered walls and the brown paint reminded me miserably of sitting over a bowl of prunes and custard.

At about seven o'clock in the morning we caught the school bus in the main square. After the children had been dropped off at the perimeter of the town, we continued out into the desert for about six kilometres to Huacachina. This tiny oasis was connected to Ica most of the way through the sand by a shady avenue of government-sponsored eucalyptus trees.

There, encircled by steep mountainous dunes, was a still, green, medium-sized lake, with various palms and a decorative balustrade all the way round it. At one end a colonnaded building with a bell tower had been washed slightly pinker than the great hills of sand behind.

It was very quiet except for the singing birds, and still cool enough to sit in the shade of a palm tree and sketch.

When it grew too hot, we walked slowly round the lake and back to the pink building. It was a hotel, built in the 1930s, and had been a very fashionable place for sweltering politicians and diplomats escaping from the humidity of Lima. Before a drop in the water table, the lake was less of a patchy red and green syrup and more of a possible health cure. Now, only a few boys splashed about and enjoyed the dark, murky water.

11

The Hotel Mossone was decaying. Its verandah was still furnished with wicker rocking chairs, several of which were occupied by the decrepit. They sipped their morning stiff drink from glasses kept steady in their shaky hands by the circular niche woven into the right arm of each chair.

The dining room was cool and dark. It had been carefully built entirely in shadow. Now it was overstaffed by hovering elderly waiters, their dewlapped chins dangling over the white starched collars of their uniforms. Elegantly dressed men were drifting down for breakfast and a nun in white tropical habit was drinking vibrant green Inca Kola.

It was eleven thirty and we wondered what they had been doing the night before.

A ballroom led off the courtyard garden, but the raised brass-railed stage hadn't supported a palm court orchestra for a long time. Great chandeliers hung dusty over the springy floor which was swept by threadbare, dark blue velvet curtains. The air felt as if it had lain undisturbed for years.

The succulents were in bloom. We sat in the dining room at the table with a view through a huge open window. Below was the lake, with the thin line of palms all around. Just outside were assertive looking hibiscus flowers, beds of amaryllis thrusting up at the same angle, mimosa, blue flowering trees, all swimming before our eyes in the brilliant light against the wind-blown mountain of scalloped sand. There was just room for a small blue sky at the top.

All alone, a photographer was readjusting the large black drapes over his plate camera.

Quietly and awkwardly, we ate our breakfast as the waiters shuffled slowly about the polished wooden floor.

The bus for Nazca left every day at 6 a.m. in the cool.

Rosie was very upset to see a small black sheep, quaking and hobbling, looking out through its sad, oblong pupils from the dark boot. We shoved our luggage in.

The diesel engines of the bus, partly due to the broken exhaust system, sounded like a throat being cleared of phlegm as we roared again down the Pan-American Highway. Very soon the vineyards stopped and the sandy shifting desert began. Overnight, huge mountains are blown away and piled up elsewhere by the wind.

Rosie worried out loud about the sheep underneath our seats.

Gradually the bus climbed up into the mountains which had turned to bony, bare pink rock. Not a bush was in sight. Only alarming shrubberies of rusty wrought-iron crosses clustered at each hairpin bend, overlooking the stark crucifixes scattered over the steep slopes below.

Passing through villages where even people's eyeballs looked dusty, the mist lifted and the sun began to beat down. We sped over the vast flat plain where the mysterious straight lines, spirals and strange configurations criss-crossed and decorated the bare stony ground.

When we arrived at Nazca, the sheep was gently lifted from the cool luggage compartment, looking more composed than some of the shaking passengers. In the arms of a small boy it was carried into a house across the road.

We found a clean hotel with a long, thin yard. The mosquito netting at the unglazed windows was newly pinned at every opening.

Nazca was desert coloured, its main square bright with flowers. Some of the buildings had been reconstituted from Inca remains. The valley that led into the mountains was green. Its water supply still flowed down from miles away through Inca aquaducts. It hardly ever rained. Behind the little town rose the bare foothills of the Andes. I looked up at them with excitement.

By dilapidated car we were driven about twenty kilometres back to the plain to see the lines. We climbed a steep, witches' double-nipple hill, and there below us, drawn across the flat, barren landscape, were the lines, pale strips of sand which had been exposed by the removal of the top layer of red stones. Funnels of little tornadoes were gently whirling

13

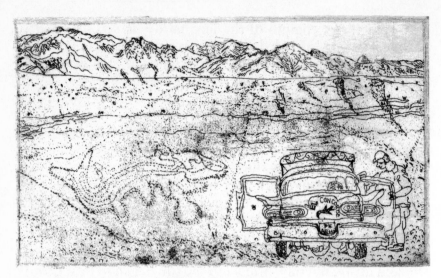

Geometric lines and effigy of a fish 80 feet long in the desert near Nazca

all over the place, cleaning the debris from these gigantic manmade designs.

Beneath us stretched the branches of the tree of life. Hands that had belonged to the shape of a lizard lay on one side of the potholed ribbon of tarmac that is the New Pan-American Highway. The remains of its torso and long swirling tail wound off into the distance opposite. It was eery and unearthly, stretching out as far as the eye could see in the haze of heat. The wind whipped the sand into our faces and eyes; the sun blasted down.

That evening Maria Reiche gave a talk about the lines. A frail old lady, well into her eighties and nearly blind, she had lived in Nazca since 1932. Originally a mathematician from Bavaria, now she lived in the smartest hotel in town. Her monologue, even though well trammelled by daily repetition, was interesting and her enthusiasm infectious. She explained that the lines were an astrological calendar for an agricultural culture where there is no rainfall and hardly any change in the seasons. It is thousands of years old, made by man and certainly not by extraterrestrials arriving

in spaceships. It couldn't have been stranger if it had been.

At the end of the evening we eased ourselves out of her hotel's easy chairs and, dodging all the clanking Chevrolets strung about with lines of winking fairy lights, returned to our simple lodging house.

The next morning we wove our way through the bamboo mat covered market. We bought a bottle of mineral water and a hat each – the sort you can wrap your sandwiches in, sit on, crumple into your inside pocket, collect blackberries in, scrub, decorate with next door's roses and wear at a wedding – fine straw hats.

We stuck these on our heads and struck out of town across the footbridge over the dry riverbed filled with rotting rubbish and into the cotton fields towards the mountains. The cotton was in flower; big yellow blooms like crumpled tissue paper. Swallows swooped overhead.

The valley was laced with an ancient system of irrigation canals, narrow footpaths running along the top of each dyke.

We wandered past orange groves, almond trees and secret gardens growing up from behind massive stone walls built a thousand years ago. Maize was still bright green and people bent double were carefully altering the banks of earth to redirect water down the furrows of newly ploughed fields. Women with lots of skirts and battered brown-black felt hats cooked soup over fires on the bare corners of fields. Babies were bundled up to the backs of their brown, crinkly grand-mothers. Children walked lambs and goats that had red ribbons tied through holes punctured in their ears, leading them by pieces of string.

There was nobody at the Inca swimming pool and, in the shade of a tree like a mimosa with huge spikes, we swam among hundreds of tiny fishes in perfectly clear water.

The heat became intense. The bathe had only very briefly cooled us. We hurried on by footpaths up the valley, following the irrigation channels. When Rosie looked as if she was going to faint, a convenient row of pines threw enough cool shade for us to rest.

I had read that the pre-Inca aquaduct that still brought all

15

the water from the high Andes to the town erupted from the ground near here. On we went, passing a washing place that was crowded with women and children laughing as they beat clothes on rocks. On and up we went, following the direction their fingers pointed until we found the water springing from the ground. It emerged in several places. Deep stone-lined conical pits had been dug into the ground, with the water running at the bottom. We climbed down and stood in the cool streams up to our waists, fully dressed.

On three sides we were surrounded by utterly bare mountains. The dip in the middle was where the road climbed up and past to Cuzco, thirty hours away through bandit country.

Under a strange tree with long pods, like a carob, with green welts and sticky furry blossom, we sat until it became cooler. In the late afternoon hundreds of minute, coloured humming birds – picaflora – arrived. We lay on our backs watching them, humming and hovering, their fine beaks poking in and out of the blossom above us.

We returned by the fields and chose a path that led us through a farmyard. A friendly family was sitting waiting for supper, which was being cooked on an open hearth in the garden. Turkeys screeched and displayed their fantails to the hens and goats and children who were playing in the orange grove among the lemon balm.

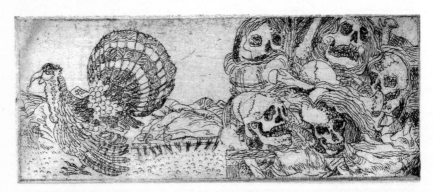

Skulls from ancient Nazca and turkeys in a farmyard

A young woman took us to a table in the copse. Lifting a polythene sheet, she showed us with pride her collection from their fields. All set out in tiers, like a well-loved collection of dolls, were bits and pieces of mummies. A shelf of leering skulls still had their long black tresses attached to the bone. All were adorned with bits of broken pottery, fragments of decoration.

So the bones we'd kicked up with our toes as we walked along were human. The fields we passed had been an Inca necropolis.

Saying goodbye cheerily, we headed back in the cool dusk along the lane towards the town. We gave the Inca belvedere, its bones and shrouds only a glance as we passed.

3
AREQUIPA

he scheduled ten-hour bus ride up into the mountains took twenty. We had waited seven hours at Nazca for a bus which had simply vanished. The next was double-booked and a spectacular quarrel between the boy in the bus office and the driver caught the attention of most of the men passengers. They clambered out of the bus over the women, sleeping children and luggage and formed a circle until all looked set for a nineteenth-century fairground prize fight. The driver won.

We heaved our bags back into the waiting room and the bus drove off with a roaring fart into the night. The boy in the office played 'Eloise' on a musical box and, when that ran down for the twentieth time, blew an even sadder tune on his row of bamboo pipes. The dogs in the village started one by one to bay and bark.

Rosie sat stubbornly aloof from my silent gloom and said: 'One thing and another, it must be the full moon.' But the sky had clouded over.

At 2 a.m. a bus going to the Chile border stopped, and we accepted a lift to where our roads forked.

The wind had got up and re-sited a sand mountain across the asphalt of the Pan-American Highway. The night mist grew dense as cold porridge as the road zig-zagged into the coastal rocky hills; the desert in every form went on and on and on.

At 5 a.m. a deathly grey dawn light seeped onto this scene from the moon, making everything even greyer. We knew it

must be dawn when a cloth bundle tied up by our feet suddenly crowed. Where physically possible, the road followed the coast but regularly climbed up and down the hairpins where the steep mountains came almost vertically down to the sea.

By now the slogans on the slopes were more political than religious and were planted out with star cacti. They flowered at night and faced in the direction of the moon before fading with the dawn. The only other plant to be seen was the occasional Lone Ranger cactus, silhouetted against an MGM sky. There may have been more plants but they didn't show up among the rocks.

We travelled on over great dry riverbeds, round and about the ribs of the landscape, through plains of more dust floating on the wind as high as the low morning mist. Desultory birds of prey swooped low, finding it difficult to take off until the rising heat of the day swung them up by their huge dark ragged wings. Over the ocean the frigate birds cruised, menacing as black jets. Large waves were furiously pounding the seashore with great breakers careering in behind them.

Buses and the biggest lorries I'd ever seen lurched at speed on this highway, barely one and a half lanes wide. Meeting something coming from the opposite direction meant a violent swerve off the tarmac and a prayer that the verge was fairly flat. Armoured cars and tanks also thundered by.

In another dry riverbed valley, in fields of sand with sand walls, grew plants individually dug down into holes, and a few olive trees – everything neatly laid out and squared off around the small, woven bamboo buildings.

As the sun rose higher, I saw in the distance a great lake with a herd of cows and goats and also eucalyptus trees, underneath which people had gathered in groups. All shimmered in the heat. At the moment I expected all to become clear, the whole scene vanished. Now I knew what a mirage looked like.

The bus continued, shaking us up through the desert to a thin, fertile valley awash with the co-operative paddy fields and crowded with people wading, bums up, sticking in rice

plants. At Camana we left the bus and resettled in another tiny bus office. We sat on bags of dried butter beans and rice, leaned against boxes, and waited, wondering, along with everyone else, when the bus to Arequipa would arrive.

The flies were buzzing and swarming, and some green insects bit our legs and arms. Across the road was a growing queue of people in straw hats, mainly women bulging out of several pleated skirts, with brightly striped squirming bundles of babies tied to their backs. Standing barefoot on the black, oil-soaked ground, they waited to fill their paraffin cans.

After two or three hours, from a cloud of dust at the other end of the valley, the bus emerged. We clambered on and slumped down into the back seats.

The bus turned east and started the gradual climb up through the pink, barren mountains. At a military post we registered with both the army and police. They were quite pleasant, but we were glad to be on our way.

After three and a half hours on and up, the snow-covered, pointed peaks of the Andes were visible against the blue sky, well above the low clouds; and then, rounding the corner of the last hairpin bend in a great switchback of road, the sudden bright green of a valley with silver water rushing through; little fields with goats and fruit trees and maize and children and tall eucalyptus trees.

I was surprised to see so many Australian eucalyptus trees – a government reforestation scheme, I heard later; and plants I hadn't seen before, strange vegetation that seemed to have been designed by patients in a lunatic asylum with the help of an indulgent occupational therapist; peculiar and ridiculous shapes and colours that the constraints of sanity would certainly inhibit.

Ten minutes later the bus shuddered to a halt at Arequipa bus station. At last the desert was below us and we were higher than I'd ever been before – about eight thousand feet.

We stayed in a basic *pensione* on Jerusalen Street. The room had two twin beds painted with unrealistic scumbling, shelves, a table and a bedside lamp. Like most of the other rooms, its French doors opened onto a paved courtyard,

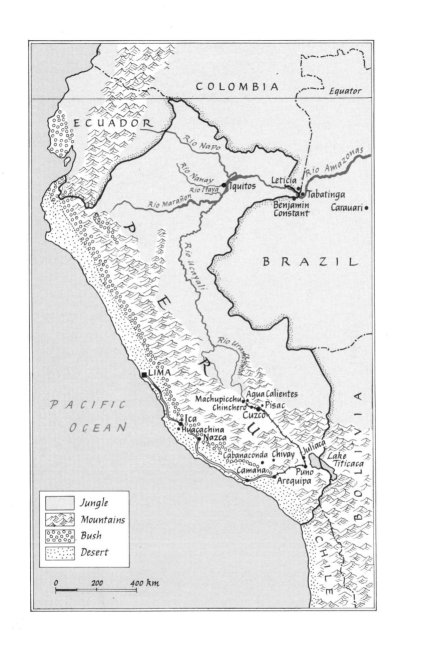

COLOMBIA

Equator

ECUADOR

Rio Napo

Rio Nanay

Rio Itaya

Iquitos

Leticia

Rio Amazonas

Rio Marañon

Tabatinga

Benjamin
Constant

Carauari

P

BRAZIL

E

Rio Ucayali

R

Rio Urubamba

LIMA

U

Agua Calientes

Machupicchu

Chinchero

Pisac

Cuzco

Ica

Huacachina

Nazca

BOLIVIA

Cabanaconda

Chivay

Juliaca

Camaña

Puno

Lake
Titicaca

Arequipa

PACIFIC

OCEAN

CHILE

	Jungle
	Mountains
	Bush
	Desert

0 200 400 km

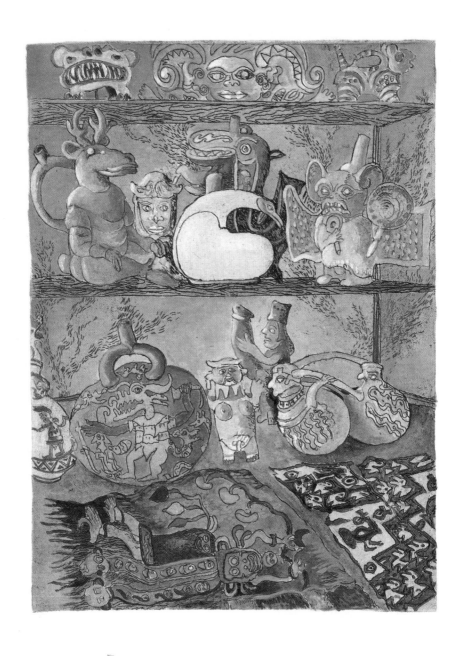

Chiclin and Mochica pottery; fragments of pre-Inca weaving

Oasis at Huacachina; Hotel Mossone

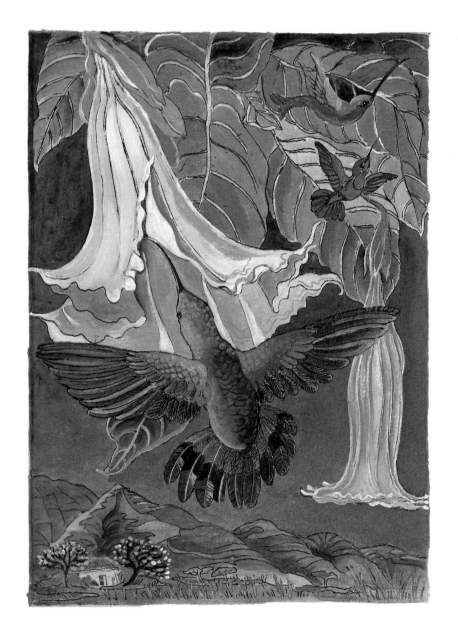

Hummingbirds sucking nectar from the datura flowers, Nazca

amply furnished with pots of geraniums, purple flowering cacti and, by the huge wrought-iron gates that were the first defence against the outside, a constrained potted rubber tree. Spider plants and nasturtiums were rampant. Tables, chairs and a three-piece suite carved from a palm trunk were constantly moved around the yard, following the shade. Tea, coffee and sandwiches were served all day and there was a laundry service. Rosie worried that it was wrong to ask someone else to do your washing; I was afraid that doing one's own would deprive the young girl of her essential wages.

Laundry corner of the courtyard at Pension Guzman, Arequipa

A great heavy pair of wooden doors were closed at dusk, shutting out the extraordinary world outside. It smelled strongly of colonialism.

At the end of Jerusalen Street rosa El Misti, a huge active volcano. At the lower end was one of the colonnades

of the main square. Two blocks across the way stood Santa Catalina, the convent in which five hundred nuns had been incarcerated. It was still a little community, fossilized in the sixteenth century when the whole town had been built from the gleaming white tufa, the sillar flecked with black ash thrown out from the numerous volcanoes in the area. Its baroque decoration was bizarre. The vigorous carved patterns and details had no obvious connection with the sycophantic encrustations the Christian Church aspired to, but a clear association with the fearful scenes on the shrouds that had been unwound from the desert mummies.

In the morning I hopped onto a No. 20 bus to the country, first to an onion field at Paucarpata where I drew the meticulously designed pre-Inca terracing curving round on the horizontal, with detailed irrigation still functioning, and the mountain behind. Paucarpata is the Quechua word for terracing.

Then on to Sabandia, where the grass was bright green by a fast-flowing stream which sped down to a water mill. The potato crop was in full purple and yellow flower, conspicuously belladonna. Grazing llamas kept the grass down around the old mill. It was perfectly quiet. Only the peaks of El Misti were visible above the mist. Families bent over in their fields; occasionally a man sitting on the haunch of a donkey rode by, his feet dragging in the dusty road.

By two thirty in the afternoon it was too hot to draw outside.

Rosie was in deep despair. The colonial rape of this country was so clear to see, the racism terrible. For several days her pall of gloom had covered me as well, until neither of us knew where it came from.

I felt impaled on the horns of the great dilemma overlooking the generation grand canyon. I had come here to avoid people, she to meet new friends. The final blow was that I was

22

her mother and felt for her sadness. We had hardly spoken to anybody but each other since we left England. Also, a lot of the time I forgot to talk.

So, alone up the hill I went through the dried park to the balustrade that brings Arequipa to a halt with a spectacular view of valley upholstered with button-tacked green fields leading away into the distance and the foot of El Misti. The mountain rose up, its folds, cracks and crevices, ridges and peaks all sharp and clear in the long shadows of the sinking oval sun. The pine trees whistled in the breeze and there was the sudden chill of dusk.

Hedge cactus and llama, with El Misti in the distance

Rubbing away the goose pimples on my arms, I returned to the courtyard, which was warmly lit by electric light. Rosie was smiling and talking to an Israeli girl.

A good distance had grown between us. Tomorrow would be better; Rosie was planning a journey that would take us away from colonial Peru.

* * *

Arequipa market was a gigantic covered centre where people from the countryside came and piled themselves and their wares. There was hardly space to walk for baskets of cheeses, piles of onions, buckets of honey, maize, parrots, precariously balanced towers of woollen cloth from the mountains; pemmican, fish, weeds; waist-high rue stinking of tomcat; spices; cinnamon stacked up like kindling; plastic bags made from fertilizer sacks and swiftly hand-painted with birds or flowers or vines; guava jelly in blocks; baskets of tiny, roughly cast votives. Monkeys were tethered next to piles of massive gnarled squashes, from which the sections were cut and sold, leaving them with gaps like ghastly grins. Mummified cats were arranged, tails down, in a cardboard box. I couldn't tell if they belonged to the dried meat or voodoo appliances stall.

Children and babies were asleep on the ground; scales were clanking up and down at a pace that blurred the hands of the operator, and calculators showed results that changed in a flash. Tinware in trolleys rattled as it was pushed through the narrow congested alleyways. The vibrant colours of plastic intermingled with everything.

At the bottom end of the market were huge slag heaps of different sorts of potatoes. There were hands of bananas looking like dozens of frenzied pianists; apricots and black figs; bowls of olives and lots more fruit and vegetables that I

Jungle Baroque carving in volcanic sillar above a doorway of a secular building

couldn't recognize. Bread filled wide baskets, and there were wicker trays of oval loaves with coloured icing-sugar faces of saints and political heroes stuck on at one end.

The whole of this lay under a cast-iron roof as high and ecclesiastical looking as Paddington station. On top were layers of corrugated iron, keeping out the brilliant light of day. An overflow of stalls poured out in a mass down each road leading away from the market place.

We bought bread and cheese and fruit and, to carry it in, a bag with a bright bird painted on one side.

For most of the day it was too hot to draw; the intense white sparkling stone and white reflecting paper were blinding, and the distance shimmered.

We planned to go higher, up into the cool mountains and the country.

4
THE ANDES

t was the end of the most amazing day.

We were high up in Cabanaconde, a village of stone, mud and untidy thatch houses with mule tracks and terracing up almost to the spring snow-line. There were icicles and hot sunshine and clear, bright air, streams still frozen at the edges.

But now I was in bed, shaky with *soroche* – altitude sickness – chomping my way through a pile of coca leaves as if it were a packet of crisps. A woman overheard me being sick and darted indoors, plunged her arm into a sack and gave me a generous handful.

Coca leaves chewed with a catalyst, such as lime or calcium, anaesthetize the throat all the way down to the stomach, and instantly nausea is cured – also hunger. It also dilates the capillaries, which helps oxygen to circulate round the body.

At 5 a.m. I awoke from a terrible, vivid nightmare, my head still throbbing. My bicycle had become tangled up in a really beautiful unravelling ball of string as I tried to cycle round Piccadilly Circus. People were trying to help me, but I just peddled on, becoming more bound up. I was looking for a telephone box.

Rosie and her Israeli friend, Nurit, were just leaving for a long walk. I felt really low and very far away from Piccadilly Circus. Several chickens wandered into my room, clucking reassuringly; they were to be my companions for the day.

We had left Arequipa at dawn in the most dilapidated bus yet – bashed and dented, panels flapping. The seats and parts

of seats were just jumbled up inside. There were not enough windows to cover all the big gaps in the sides. Ladders led to the roof which was piled so high with luggage I had to stop myself from trying to estimate the height of the centre of gravity. People crammed in with even more bundles. Everyone was carrying a blanket in case the bus broke down and we had to spend a night in sub-zero temperatures on the bare mountain.

The dirt track zig-zagged up and swooped over the pass between El Misti and its neighbour, Nevado Chachani at over four thousand metres. The high pampas we sped through was covered with big clumps of itchu grass that looked in the morning light like a million startled porcupines. Wild alpacas grazed and gracefully bounded away as we passed in our cloud of dust.

The mountains looked as if the gods had bought up the entire stock of a plasticine factory, roughly mixed all the different colours and bent and folded them before throwing them down in this part of the globe.

Up and up we ground, slower and slower, until the vehicle was no longer moving. Black, choking fumes filled the bus. Most people took the opportunity to have a pee, men turning their backs when not talking to a friend. Small boys competed spectacularly and the women just stood, their legs slightly parted.

The two drivers opened the engine casing and dismantled various parts. In an hour or so the metallic clinking of spanners had stopped and all was successfully reassembled.

Most women were wearing clothes that couldn't have changed much in style since medieval times. Each wore at least two heavy embroidered skirts, the top one hitched up to reveal the next layer, also filled with bands and embroidered animals and birds and symbols and swirls. The folds of the top skirt had become a useful and usually full large pouch.

They wore jackets and hats embroidered with the same comic-strip illustration that decorated the pre-Inca clothes, the pre-Inca pottery, and even the carved baroque churches. Generally, everybody was beautiful: the babies, the children,

27

the young and the elderly with their thick black plaits. Only the very old were grey. Everybody wore a hat.

We travelled on, stopping to let passengers on or off at the bleakest places where sometimes only a faint track led over a distant ridge, to be walked with great bundles of shopping in the heat of the day with not a shadow in sight.

Occasionally we passed tiny mud hovels with wild itchu grass thatches and the accompanying stone-walled pounds of the llama and alpaca farmers. Built from and in the landscape, they were barely visible. The herds of animals were often noticeable only by the cerise or scarlet wool tassle tied to the rims of their alert ears.

A strange river spanned right out over the plain, running neither definitely below nor above the ground, with hundreds of pale green humps of moss in it, providing a panoramic vista of velvet-covered footstools. Cows were gloomily standing in the lacy ice on the water, chewing the cud.

Once over the pass, hairpin bends took us down to Chivay in a vast valley of ancient terracing and field systems in every sort of brilliant green, yellow and brown. It was still meticulously cultivated, the irrigation canals carefully maintained. It took precedence over the modern highway and our speed was reduced to walking pace as the great double wheels of the bus felt their way through the channels which crossed the road. High up the mountainside groups of people bent over their zappas. Teams of oxen ploughed in the lower fields.

We stopped in the village; half an hour's break. Apart from the activity around the bus as luggage was taken off and more piled on, everywhere was deserted. The market was all set up, but nobody was there. We wandered about, slightly lightheaded from the altitude. In the distance we heard a sad, slow dirge being played erratically on trumpets with a backing of heart-rending, halting drumbeats.

We turned a corner and there in the centre of a medieval crowd, cowering under a precipitous hail of rice, was a sad wedding couple, standing next to but quite apart from each other, a look of fear in their eyes. They appeared to be about

28

fourteen years old. The bride looked very shaken, the sweat on her forehead running down her face; she was wearing a brilliant white nylon gown. Offering no resistance, she was being pulled along by the white ribbons attached to her waist and held by small children. The bride and groom each peered dismally over a bulky loaf of bread, representing the tree of life, that filled their arms. They were being led, a miserable spectacle, all the way through the village.

We returned to the bus, which was hailing its passengers with a lively blast on its horn.

Off we went up along the brink of a gigantic ravine, a river foaming along in miniature at the bottom. All along this ridge the express from Arequipa stopped at villages and picked up dozens of thick skirts, bundles, sheep, lamps, chickens, vegetables, wicker mule paniers, more children and more babies, more hats, blankets, sheets of corrugated iron; 'Swan, made in Japan' flashed in the sunshine as it was offloaded to replace the itchu thatch.

Slowly and carefully this overladen public conveyance lurched, as if on four feet, along the track rutted as a riverbed, until at teatime it stopped in the big open square of Cabanaconde. Anything detachable from both inside and out was quickly piled up on the pavement and the bus driven away.

The late afternoon shadows were beginning to give a depth to the landscape and buildings and a slight breeze helped us to take deep breaths.

Grey with dust I stood and looked at this village which, but for a crumbling massive sixteenth-century Spanish church, could not have changed much since pre-Colombian times.

It was still quite early when I left the chicken scratching and optimistically pecking the earth floor of our room.

Carrying the paper bag with the remains of the coca leaves and a drawing book, I walked towards the fields. The

Backstreets of Cabanaconda

narrow street was cobbled, with an open drain running sluggishly down the centre. Chickens and brown spotted pigs paddled and routed as they scavenged among the refuse.

Men riding donkeys picked their way to the fields. Women were walking, carrying babies or bundles on their backs and spinning as they went. Everyone seemed to be on the move to the fields, radiating from the square where a few stalls were being set up in the gutters.

Breast-feeding mothers lifted up specially embroidered flaps on their blouses and sat on rocks, doorsteps or sacks of rice to suckle their babies before rebundling them, retying them across their backs and continuing with their work.

I continued up another cobbled street to the end of the houses and out by mule track which was enclosed each side by stone walls, their tops sprouting cacti to keep the animals out. The livestock was free to roam anywhere in the little town but was kept out of the fields of crops.

I sat on a wall, and the morning procession continued to pass by. Mules, donkeys, goats, sheep and lambs, cows and calves accompanied the people; and a bit later came a second wave, mainly children carrying large clay water cooling jars strapped to their backs in the usual way with ropes round the

shoulders. Usually the narrow neck was stoppered by an onion or complete head of garlic.

The wheat was harvested and the straw laid out in neat, straight bundles ready for rethatching.

Most people stopped and asked to see my drawing book. They loved the mountain sketches and seemed really pleased to see a stranger taking time to look. They knew it was an extraordinarily beautiful place. By now I was happy to be so far from Piccadilly Circus. When I moved back to the village to draw some of the carved doorways, a wake of young girls followed.

By noon the sun was hot and I began to feel quite ghastly. One of the girls, bolder than the others, invited me to her fields across the valley, but her mother put a swift halt to this attractive idea, and told me to go back and lie down. I must have looked ghastly as well. By the time I reached the room my lungs felt as if they were splitting, along with my skull.

Two hours later I woke up with a light spinning head. The chickens had gone to roost in the yard.

Slowly I walked out towards the ravine, towards the edge of the fields and past the large, perfectly round, stone pound.

A dozen donkeys, with their heads lowered, were hanging round inside, standing on the bare earth.

Broad beans were ripe and maize was still a luminous green. Dozens of vivid green parakeets flitted in flocks from bush to bush as I picked out the path through the rocks and cacti, which were flowering white and yellow and red, their scent strong in the still early evening.

At the edge I sat and looked down to the bottom of the canyon. Here it was one thousand feet deep.

Paths zig-zagged all over the mountainsides from village to terraced fields and down to the lush green vegetable gardens and orchards by the river. This was where Rosie and Nurit had gone; two hours down and three hours back, they had been told by the village people whose gardens they were.

I cautiously peered over the cliff edge; there was no sign of them.

It was so quite that voices miles away across the ravine were distinct. I could hear the sounds of children playing in the village, horses' hooves on the rocks, chickens, sheep and cows. Most amazing was the swoosh of the wings of the swallows as they swooped overhead.

All around was layer upon layer of mountains, growing smaller and flatter in the distance like the cardboard sets of a Pollocks Toy Theatre. They were magnificent against the clear blue sky and bright light.

In the late afternoon the first chill was brought in on the breeze and I returned to the open square to sit on the kerb and drink a tin mug of herb tea made on a paraffin stove alight in the gutter.

The procession returned from the fields. Everyone was laden – with dried cactus faggots, dried animal dung, onions, herbs, maize leaves; kindling sticks and fodder, straw, toma-toes, pears. The loads were sometimes so large that only the legs of the bearer were to be seen sticking out beneath. The donkeys, too, were stacked high with loads. Children led the animals and the babies seemed to be asleep.

The sun was dropping rapidly behind the mountains and candles were lit indoors. The snow on the peaks had turned

pink, and I wondered why Rosie and her friend had not returned – they had been gone for twelve hours. The last of the people straggled back from the canyon, and a boy carrying a huge wooden plough over his shoulder and driving laden donkeys said he had passed them on the way up.

Nurit is twenty-two, with long, black curly hair, brushed out well past her bottom. She left Israel for South America immediately she was discharged from the army, having spent two years posted on the western frontier.

Even so, I began to worry. The man from the 'hotel' finally understood that I wanted to borrow a paraffin lamp and not a match.

Being a parent certainly puts reason in the shade, and I started to think of the cold, their thirst, broken bones, bleeding to death, poisonous snakes and, finally, bandits.

'Bandits?' I asked the man as he filled the lamp. He grinned and, drawing his finger across his neck, made the universal throat-cutting sound; a joke, he added.

Out again at the edge of the canyon, I stood and called out into the dark. I heard the echoes bouncing fainter and fainter all over the mountain range. Again and again, only my voice answered, 'Hello, hello, hello . . .' And then, listening carefully, I heard the familiar echoes of different voices, 'Hello, hello, hello, okay', and half an hour later they arrived, shaking with effort and exhaustion. It was a two-hour walk down and three hours back even for the sprightly old ladies under their loads, but it had taken them seven hours to climb up from where they had swum.

'I just couldn't catch my breath,' Rosie said. Their pockets were still full of coca leaves the passers-by had given them.

In the candlelight of the shop we drank tea and I listened to their description of the Garden of Eden by the river, where people go to cultivate in the course of a day's work.

*　　　*　　　*

33

Breakfast time in the square: big mugs of tea and bread like little dry pitta. We sat with the women and children round the kettle in which herbs brewed. A few vegetables were for sale, but they were mainly exchanged for other goods. Very little money was used in this community. Most people could never afford the return bus fare to Arequipa – not quite three pounds.

Everything in the landscape under the everlasting blue sky was dry earth, so the women's clothes by contrast were even more brilliant, and intensified by the sunlight – blue, green and purple; cerise, scarlet and orange; a blouse, a waistcoat, a jacket, two skirts over petticoats, a hat – all in velvet or wool. All illustrated with friezes framed by woven braids. The Cochineal beetle is harvested from the nopal cactus and produces dyes that range from reds and purples to black. The women liked the red cabbage-rose print of my petticoat which I wore under the black, embroidered dress. But who was I mourning for? Why such a dull colour? We were eventually directed to the men who make the clothes.

Each sat by the open doorway of his windowless home, drawing directly onto the nearly finished garments. Free-hand they outlined the detailed pictures and patterns in white thread on their treadle sewing machines, and without hesitation the pictures appeared as wide or narrow borders. They were later coloured by hand embroidery.

The oldest women, in their seventies and eighties, were dressed in faded, patched fragments of once even more beautiful clothes, handwoven and lavishly decorated, each very individually, I imagined by their mothers. That was the everyday wear.

Most people speak Spanish but use Quechua, their own language. A child looked towards the church and said, 'They had to make us slaves to build that.'

* * *

After drawing for most of the afternoon, I met Rosie by chance in the square and we walked together towards the café. Alpaca, rice, vegetables and herb tea cooked while the mother made a green and silver paper Christmas tree with tinsel and wire. Chickens were allowed to wander in, but not the dogs.

Two astonishing caricatures of machismo came swaggering in, their huge wool ponchos and black, wide-brimmed hats throwing exaggerated shadows on the wall before they sat down. Two mugs of black coca tea were quickly put down in front of them. Candles were lit and their gold teeth flashed. There was not a flicker of an expression to indicate that they were anything but tough, hard, relentless men – as real men should be. Not a word was spoken.

We sat uncomfortably in the tense silence. I glanced up for a second in curiosity and caught in that moment an unflinching dark eye camouflaged in the dark face by the shadow of the hat. The other man just stared at Rosie.

The Christmas decorations had been abandoned and the family stood round the walls. I stirred my sugarless tea.

They tipped back their heads and poured their tea straight down their open throats, replaced the mugs on the table, stood up and, swiftly wrapping their cloaks about their bodies with swirls that arched out across the room, left into the dark, moonless night. Real pantomime bandits.

The family relaxed, and work on the family Christmas tree was resumed. I began the job of chewing the alpaca meat.

Every day the battered bus left Cabanaconde for the fifty-kilometre journey to Chivay at four thirty before dawn. It blasted its horn to wake everyone up.

At four twenty we arrived just in time to see its red tail light jog up the disordered cobbles of the main street and disappear over the hill. For half an hour we walked around, cross and disappointed. Maybe the lorry parked by the post

office was going in our direction. Cabanaconde is at the end of the roadway and, although dozens of mule tracks fan out over the mountains, any vehicle must go east.

While the big stars faded and the morning gradually got going, we sat again on the familiar kerb warming our hands on mugs of tea and eating tough bread that was as tasty as a manila envelope.

Two men climbed sleepily over the back flap of the lorry and, as we got near enough to ask them for a lift, became recognizable as the bandits from yesterday. In the daylight they were perfectly friendly; yes, they'd take us halfway there, and they helped us into the back where we lay on the mattresses that had been flung in on the piles of sand.

Soon after waving goodbye to the bandits as their battered vehicle tipped down to a village we flagged down a gleaming white transit minibus, already stuffed with English tourists who had come to see condors but hadn't.

Nobody spoke to us. Perhaps the heavy smell of animals that we'd picked up during the first lift silenced them. They hardly answered our questions and grimly gathered their print dresses to their thighs. The Peruvian driver smiled with satisfaction and ostentatiously refused our offer of payment when we got out at Chivay. Our farewell waves were ignored.

Chivay is another ancient settlement. The clothes the people wore were similar to those we'd looked at so closely in Cabanaconde, but the hats were different. Instead of bowler hats encrusted with embroidered illustrations, they wore birthday cakes on their heads – blancoed straw decorated with tinsel and rosettes, braid and ribbon. Every woman wore one, every day and all day.

As evening drew in, paraffin lamps lit the market and the pavement round the town's perimeter; shops sold everything in the gloom, tea was brewed over the gutter fires and the church bells rang cracked. Instead of ringing out over the town, the sound waves seemed to fall dead over the cinema, which was grinding out its distorted soundtrack through open doors onto the square.

It looked as if Bunuel and Polansky had collaborated on a film set. The gleam in the glazed eye of the alpaca's head on the meat slab was caught by the light of a passing lamp held up by a young woman in sacking skirts and carrying a tin pail of dusty milk.

The same church bells woke the town at five thirty in the morning. Relentlessly it rang, and so we too were up in time to catch the early bus back to Arequipa.

Having little suspension, the driver took the softer, sandy paths to lessen the exhausting jolting. We saw tiny villages, huge herds of llamas, desert hares and, most exciting, the great condors gliding and swooping in the highest mountains.

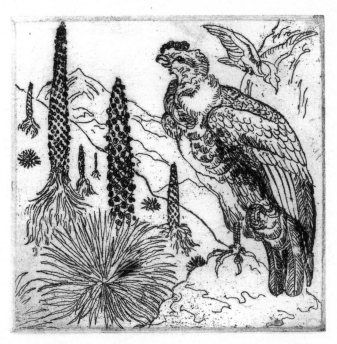

Condors and Puya raimondu – pineapple family

It was Rosie's birthday, and when we returned to the courtyard of our *pensione* in Arequipa, Nurit had collected together everyone staying there and bought a vividly iced

cream cake as fancy as a Chivay hat. It tasted as sickly as it looked and we all ate too much. Lots of tea washed away the sweet taste, and we all decided to go to see *Fitzcarraldo* at the arts cinema down the road.

5
LAKE TITICACA

n preparation for the journey to Puno, we did the washing and bought railway tickets from the station, which from the outside gave us hope that Brighton Pier was beyond its doors. It was a long walk, and even at this altitude we got tired as we rushed along in the hot and muggy day to buy enough food for the ten-hour train journey.

I looked again at the jungle baroque carvings. It was peculiar, for everything was nearly just right, but with an element that was bizarre and threatening.

Outside the *pensione* a policeman leaned against the wall licking an ice-cream, his machine-gun dangling from his shoulder.

It was my last look at the glistening buildings, so I took a bus ride to a little sixteenth-century church on the perimeter of the town. It sparkled in the late afternoon, a rosy glow as the sun set. Demons and vines and sickly pious saints, scrolls, leaves and tropical flowers twined in stone around and over the doors, snaking along with bunches of electricity cables before they disappeared through holes in the fabric. It was as if I was peering into a small slice of monochrome tropical forest.

Inside the church the walls were plain white with the statutory number of tawdry deities: Christ bleeding profusely and dressed in a waitress's frilly apron; other men depicting all the popular sado-masochistic Christian poses; Virgins in velvet frocks decorated with scraps of angels and flowers, wringing their hands; papier-mâché angels up to their waists in papier-mâché fleecy clouds.

There were also some really beautiful paintings that I was beginning to recognize as the 'Cuzco School', painted by Indians in the seventeenth and eighteenth centuries in a style that reminded me of Duccio. They had an honest, primitive quality, without sentimentality.

Outside, the white stone of the piazza was luminous and the trees dark silhouettes in the dusk.

A new moon had risen.

For several hours the orange and yellow striped caterpillar train climbed up, winding up the white, frozen mountains at such an incline that things slid off the table.

We travelled 'buffet class'; the carriages were upholstered with blue velour, on which white linen antimacassars were hung. A waiter in a white jacket appeared between continual games of poker to bring anything we wished by way of food and drink – oxygen also if necessary. But we stuck to *maté de coca* and our own sandwiches.

The tea was warm at least.

The doors between the carriages, as well as those along the sides, were locked and a pair of soldiers roamed up and down with a spine-chilling array of weapons.

Big herds of llamas and alpacas roamed the plains and slopes, and dotted around were the disintegrating settlements of the famous herdsmen. They walked far and wide with their grazing flocks, and there were shelters built from piles of the smaller, smooth boulders that lay scattered as if they had been violently expelled from deep inside the earth by the surrounding volcanoes. Thatched with grass, they had no windows, no chimneys and only a tiny hole for a door. The wool of the flocks grew thicker, as did the locals' clothing, as we went higher and the temperature dropped. We passed strange areas where the soft white rocks had been weathered and eroded until the plain looked as if it was filled with tightrope walkers contorted by individual anguish.

We travelled up through the first damp layer of mist until the blue sky began to fill with huge blue-black clouds and the faster billowing white storm clouds. Then there were big whirling hailstones, forks of lightning and the unsettling boom of thunder.

At walking pace the train steamed on up for an hour, winding round the edge of a huge lake, gradually hauling itself up onto a plain where the pale, worn, yellowing green upholstery of the hills glowed in the slanting sunshine and an evening rainbow arched over the river, which flowed eastwards towards the Amazon and the Atlantic.

Across the plain, stopping at brown mud villages in the drizzle, the engine pulled the train at speed, travelling through the flat land where the slightly tight bowler hat perched on the round heads of the Indians working in the fields.

At dusk we came to a dissolving, rain-washed mud brick town, Juliaca. We sat in the gloom of the huge junction and shunting station, watching from the train as dozens of people tried to sell something. Only the militia stood apart from the clamour; they merely loitered with intent, smart in their army issue and twiddling their guns casually.

Engine-less, we sat for an hour until suddenly we were shot from our seats by the impact of what we later learned was the train from Cuzco becoming an integral part of us. The waiter, still losing his earnings at cards in the candlelight, was propelled by the impact through the door and landed by our feet, grubby and swearing.

A brick projectile hit the window, and we set off for Puno.

It was only another hour before we reached lodgings, cold, wet, tired and frightened. Puno is nearly 13,000 feet up in the Andes. It was difficult to sleep, and our heads throbbed.

By Lake Titicaca we sat on very ugly municipal concrete benches on the end of the pier that divided the small ferries

41

and fishing boats from the big ships. The train ferry to Bolivia and a large passenger vessel were tied next to a startlingly unseaworthy collection of peeling and rusting naval vessels.

Wagnarian clouds steamed in repeating patterns across the sky.

It had been spitting with rain as we went out into Puno in the early morning. The whole town had just finished setting out its market over every piece of flat ground, leaving narrow paths to walk through. Originally a disreputable silver mining town, it is now the big wool market for Peru. Spinning and knitting went on all the time, stuff was woven on all sorts of looms. Piles of wooden crochet hooks, knitting needles and spindles were piled on the ground, along with woolly baubles and ribbons to tie onto the long black plaits; pottery, nails and combs; spices and onions and sacks of live guinea pigs; dyes and tinware and clothes. There were oddly classified loo rolls and coca leaves, while the little lime blocks it is chewed with were along the lane with the padlocks.

The potato area was very impressive. The monstrous lorries, lovingly named and painted, were decorated with as much style as a showman's Scammell tractor. They had been backed into a semi-circle and, with their tail boards down, each displayed a slightly different side show of family life which continued inside, each group sitting on their own hillock of their own variety of tuber.

Women selling potatoes in the shade of the lorry, Puno

This was the eastern limit of the perched bowler and already there were a few burnt pie crusts in felt worn over black scarves. The voluminous stiff skirts with circular tucks were usually velvet, many embossed with metallic thread or stencilled in gold like Indian restaurant wallpaper; they reached down only to the knee and were tied over four or five flouncy petticoats. Over all this was worn a decorative apron. On top of each head sat the dark bowler. These stout ladies resembled lampshades.

Again, the embroidery on my black dress was admired and the skirts lifted to look closely at the roses printed on the petticoat. I decided not to exchange it for a woven blanket; Rosie was relieved.

The street-cleaning pigs routed and snorted as they pottered along in families, spotted brown, ready not so much for the pot as for the pantomime.

The main plaza had an unusually diverse selection of topiary: three-tiered cakes, llamas, birds, warships, chimera, chessmen and watchtowers, all giving shade to nursing mothers and the Saturday drunks training for Sunday. On one side of the square stood the Palace of Justice; opposite the ornamented barracks, up a wide flight of steps, was the cathedral, the façade carved magnificently with St Iago, his scallopshell, two mermaids smiling, all hiding in the Amazonian forest with birds. It was closed until Monday. I stood at the top of the steps to view this little colonial square. In the centre of the garden below, on a stone plinth, was a bronze Spaniard pointing a pistol straight at St Iago.

The houses had wrought-iron windows and balconies almost drawn with pen and ink. The façades were decorated with crumbling stucco scenes, roofed with jumbled pan tiles and patched with corrugated iron. The place was crawling with soldiers, both the civil and military police; they stood, a pair in every doorway, unsupportive caryatids.

In the early evening I went out for a cup of tea. The bread, in large deep baskets, had arrived still warm from the bakers. Families were cooking their supper on stoves in the gutters. The meal was displayed in the cool twilight on planks of wood

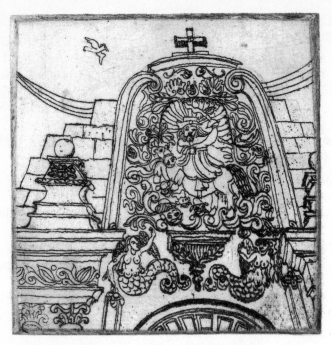

*S. Iago of Compostello carved over the main
doorway of Puno Cathedral*

laid on the ground. Children sat on the kerb waiting to eat. Babies were being fed and repackaged, and lamps were being lit.

By the time I had drank the *maté* it was quite dark and the market was being packed up and taken home. Massive loads were being heaved onto the backs of even the tiniest and oldest men, who staggered away bent into a right angle at their hips.

A dense, black blanket of cloud was drawing rapidly across the sky, but by the time it began to pour with rain the streets were quite deserted.

* * *

I don't know whether it was the great weight of handwoven blankets, the thin air or fear, but all night long I woke up unable to breathe deeply enough. I was glad when morning came.

It was just after five when there was a persistent knocking on the door and a voice announcing hot water – not exactly true, but there was water. Even spinning out the breakfast coffee and choosing the picnic tomatoes with extra care, it was 7 a.m. when we set off through the town towards the hills to the north.

Apart from the government-supplied eucalyptus, spindly on the wind-swept slopes, the landscape was generally brown and barren, most of the terracing abandoned. But at the fringes of the country, the hillside shanty towns rose up steeply from the shores of the lake. The houses, made of mud bricks, had been home-made to the wrong recipe and had dissolved in the regular heavy rains. They had the smooth quality of melted chocolate. Pigs, dogs, chickens with bare pecked arses, sheep and lambs stumbled about the lumpy plantless earth among drifts of rubbish and the occasional rotting carcass.

We staggered up on a completely false trail, then descended hurriedly to the level of Lake Titicaca, where gradually the countryside began.

Across the road, thousands of little black frogs, the size of big bluebottles, hopped; thousands and thousands, a wide, black carpet, running from the seeping drainage ditches of the dwellings above down to the lake. It was a tricky business picking our way through this procession on tiptoe. It is from here that the bulk of frogs' legs are supplied to the world's kitchens.

Turquoise blue dragonflies, their transparent wings spanning six inches, flitted near the water where cattle stood up to their necks in the cool, munching the weed that drifted by. Small flocks of sheep, pigs and a few llamas grazed the springing grass on the shore.

Taking a narrow path through small stony fields growing miniature crops and herbs, we climbed up to where the pink

rocks of the mountainside took possession of the land again. Below, tiny thatched farms dotted the lakeside, each farmyard enclosed by a thatched wall.

It was growing hot even in the wind.

Over the ridge of the peninsula we sat on a flat rock, breathless. Beneath was a little village with a dozen or so boats tied up nearby. Some were being punted across the reed beds for fresh supplies. Further out was one of the larger floating islands, built entirely from rushes by the Uros Indians hundreds of years ago in desperate retreat; their boats and houses, too, were built from the quickly rotting tortora reeds. We could clearly see a Saturday football game in full swing. Beyond rose distant mountains, and the gap through which the ships sail to Bolivia.

We went back down the rocks to the railway line built on a five-mile causeway on the water's edge, and skipped and jumped along the sleepers to the town. We passed under the bows of a pretty steamer, tied in the fields, and a similarly abandoned and attractive bucket dredger.

It was one o'clock when, at the same moment as a black funeral cortège, we turned into the main square. The large coffin was shiny and black and nearly crushed the bowed backs of the black-suited bearers. Sweat dripped from their faces. Long black ribbons radiating from the coffin were held by children dressed entirely in black. There were black shawls, black skirts, black petticoats, black aprons and even black bundles of silent babies. On the death of a near relative, clothes are sent in bulk to the dyers and returned in right and proper mourning black in time for the funeral. Only the women's black bowlers remain the same. In silence the dark procession passed by, slowly dragging its feet as we sat in a café drinking tea.

It was dark and really cold when we went out to buy the picnic for the journey the next day, so my interest in the display of underwear was more than academic. Those for women were bulky and enveloping – hand-knitted woollen long-johns, long ribbed vests, thick lacy crocheted petticoats in luminous shades. And there was an astonishing range of

men's pants decorated with photographic prints of roaring lions, hot-dog rolls, cobras and fast cars; and vests with chest-size pictures of Rambo and portraits of Sylvester Stallone. All were in full colour.

By resisting a cerise woollen petticoat, I continued to be cold.

Puno is a port, railway junction and border town. In the suburbs are cocaine kitchens that the authorities don't dare disturb. I wanted to leave.

6

Cuzco

e bought first-class tickets (not the elevated buffet class) and the train was packed. Everyone was kept waiting until five minutes before departure time when, with a powerful rising surge, everyone pushed into the carriages.

An Australian mountaineer was padlocking his rucksack to the luggage rack. 'Look out for the man behind me, he's a thief.' Pausing to help Rosie push her bag up there as well, I looked down and both the man and my bag had vanished.

The Australian leaped out of the carriage shouting. Rosie followed with the police in tow, waving truncheons above their own and everybody else's heads. Other people joined in the chase, jostling, pushing, crashing and spinning off those who were still trying to work their way onto the train.

When it became clear that there was nobody to catch, the chase petered out and Rosie and the Australian, Noel, returned and disconsolately suggested I write a list for the insurance claim.

All the things I valued had been in that small bag. It wasn't the camera and lens, but all my drawing books, maps, films, notes, that made me want to be at home, out of this wretched country.

We sat rather grumpily and waited for the train to leave. Half an hour passed, one hour. Suddenly the compartment was filled with excited policemen, all talking at once. One held a black plastic bag.

'Look inside,' the police said.

'Look inside,' the other passengers cried.

And inside was my bag.

'Is it complete?'

'Yes, it is complete.' And in relief and real surprise we all laughed and clapped hands and thanked everyone.

It had been found under the train. Two people had been arrested.

'I imagine that's an unprecedented recovery,' said Noel. 'Surprised the police didn't take at least the camera.'

The Australian was a hardy, well-seasoned traveller and climber. As we soon began to notice, he was always prepared for the possible and never unexpected disaster.

Finally the train set off on the day's journey to Cuzco in the mountains north of Puno.

I still felt angry and shaky, especially as I began to realize the scale and professional organization of the thieving. A lot of stuff had been stolen from our train, mine the only bag returned. The ticket inspector must have been involved and I wondered why the police weren't.

Thieving is a necessary profession in this country. The less organized beg. There is nothing else. Peru is corrupt and on every level there is an uneasy tension, whether from the ranks of armoured cars with sly protruding guns or the gangs of young children secreting razor blades with which they slash your bag, catching the contents before they hit the pavement. Rosie and I have both had our bags slashed while wearing them over our chests.

In the mountain villages north of Cuzco this is civil war. Nobody is quite sure what terrorism is the work of the army and what is guerrilla activity.

'Photocopy all your drawings and send them home,' said Noel as he neatly spread his bread and cut his cheese.

The carriage was jam packed with buskers, jugglers, cripples, stale chocolate vendors, stacks of empty Coca Cola crates. There were beggars, prizefighters, conspicuously armed soldiers, drunks, and whole co-operatives of thieves reading books upside down and glancing ham signals over the tops of newspapers. People were selling almost everything that would fit in through the doors, from legs of cooked ham

to fur mats with terrible pictures of llamas in varying colours. Bananas, cakes, fags and the two terrible processions slowly worked their way up and down the train and never came to a halt.

It is their profession. We had demonstrated our wealth by buying first-class tickets. By being so far from home.

The country passing by the carriage window was spectacular. We were travelling through a deep fertile valley, the steep slopes of the mountains shooting up on either side. The snow-line seemed just out of touch at eye level. The railway track and the river criss-crossed all the way. Huge flocks of glossy ibis waded in the wide shallow water beside the cattle and buzzards soared in the air above the grazing cows, sheep and llamas. When the river narrowed, it gathered speed on its way towards the Amazon. There was sunshine and rain and rainbows; watermills and bread ovens; mud bricks laid out in lines to dry.

The villages looked more prosperous and some houses had two storeys. The fields were thoroughly worked, every square foot cared for, ploughed by oxen and by men. Arcs of seed were being broadcast from pouches of skirt, people spun and wove, all clearly visible through the train window.

Every time we stopped at a village, children and beggars climbed up and in through the doors and the windows. Nobody ever seemed to leave.

The train was running two or three hours late. This meant we would arrive in Cuzco in the dark. The train seemed to be inching its way along and when the dusk fell the darkness was black. The lights inside the train flickered and faltered. We waited for the thieves' bonanza – the total failure of the train's electrical system. A black-out.

At one moment the train stopped like a bucking horse. Two men, knives at the ready, were trying to throw each other out of the door. Many doors had flapped open with the general jolting of the train. There was a police chase along the embankment and then we were off again into the pitch-black night.

More beggars clambered in. By now we could hardly

breathe for the pressure of bodies and baggage. It was by accident that one met, for a flash, the cold mistrusting eyes of the people.

At last we reached the end of the line and the train clanked to a halt. It was still hissing up by the buffers as the great mass disgorged itself onto the platform and in a great phalanx headed out of the station. Last of all, we hauled ourselves and bags off the train and joined the slow flow out beyond the wrought-iron gates, past the police guard with guns at the ready, prodding stragglers back into the main stream.

'What have you got in your bags?' Noel was disapproving.

By taxi we went to a *pensione* near the centre of town. Round a flagstone courtyard, through huge rotting wooden doors and iron gates, and up deceptively decorative stone stairs we reached a carved wooden balcony and off it quiet rooms in a seventeenth-century Spanish palace.

I lay on the bed, miserable, wilfully forgetting that soon my spirits would rise.

In the morning the sun lit up the whole courtyard and shone through the scrolls of the iron grid at the open windows of our room. The heavy carved wooden doors swung open onto the balcony which overhung the courtyard on four sides. Couches and tall thin potted geraniums on tall stalks furnished the undulating floor. The whole structure creaked like a sailing ship as people began to wake up and walk about.

But we were tired of cold showers and our legs ached from lavatories that didn't flush and on which we didn't dare place our bottoms. And couples that only stayed half an hour.

With an address faintly written on a piece of paper, we turned out into the cobbled streets. Under wooden balconies carved with lyres and foliage that stuck out from each first floor, we walked down to the main square and up to a large

pair of doors, with a brass knocker cast in the shape of a girl's hand hanging limply from a lace cuff, barely clasping the ball that clapped the echoing thud. Finally the door opened and there stood an elegant lady with white hair, and an open smile.

A room was available in her house.

A polished, curving wooden staircase led past a tiled hallway crammed with mirrors, their frames launching pads for buxom golden cherubs on swirling gilt clouds, horned gramophones, semi-circular marbled slabs on tables with bent knees and lion's feet, painted marble furniture and chairs to match, dusty chandeliers, ormolu clocks crammed as rush hours and stopped years ago. We went up through the mouldings on the ceiling to a landing filled with pale potted twilight plants on lace-covered tables, marble pillars, mahogany pedestals, shelves and hat stands filled with 1920s hats, each about to turn to dust. Plants listlessly dangled down or were propped upright with sticks, growing towards the distant light of the glass roof. Frail sofas were upholstered with remains of embroidery, ornate frames surrounded pictures of relatives who must by now be dead and huge views of Scotland with stags at bay up to their ankles in water and bellowing across the purple hills.

Through white lace curtained French windows and a small closet we entered an entire bedroom suite filled with

Birthday cake, embroidered hat and belt from Cabanaconda;
hat from Chivay

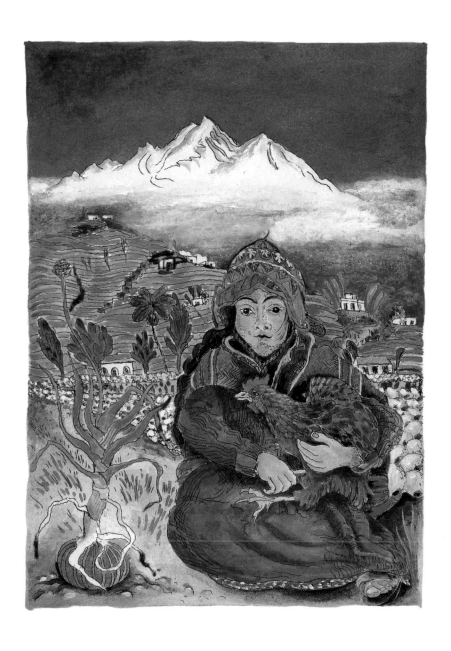

Volcano El Misti and the extinct Chachan; pre-Inca terracing of Paucarpata

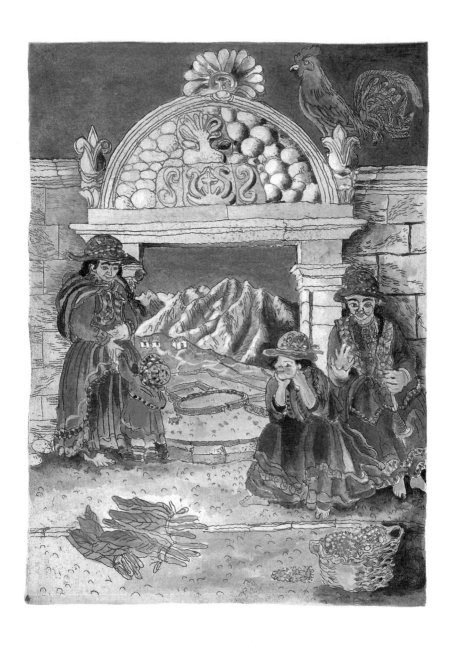

Cabanaconda overlooking the Colca Canyon

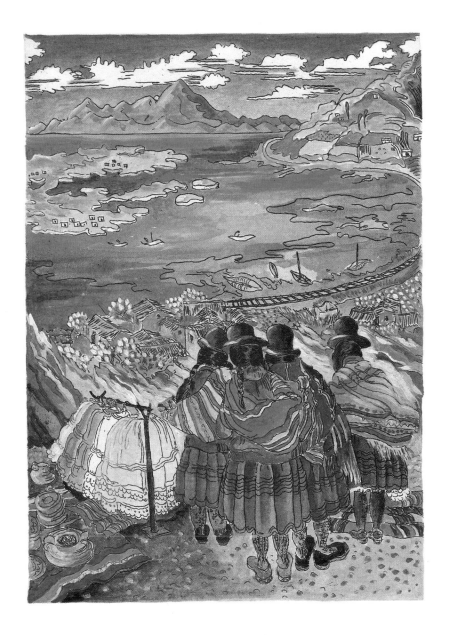

Women choosing petticoats on the shores of Lake Titicaca; the floating islands of the Uros Indians made from torora reeds

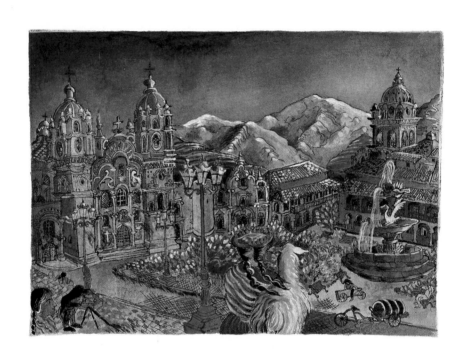

Plaza de Armas, Cuzco

monuments from the last century. The room was dominated by a huge dark mahogany bed and contained a desk, a chair, wardrobe and bedside cupboards, as well as another pair of French windows, the white curtains ballooning out onto a balcony.

The view opposite was of the massive stone structure of an Inca fortress. Down and up the road towered the mountains. Next door were the barracks with soldiers in toad green on their desultory guard duty.

We were fifty metres from the main square.

A courtyard led to an antique bathroom – in working order with hot water and a stone water filter made in England. Two maids in uniform were connected to the palatial downstairs by a wind-up field telephone.

It was quiet and beautiful. At last I felt safe.

We unpacked and hid the empty bags under the bed. Noel lay on his bed in the little dressing room. Scratched Chopin drifted sadly up the stairs as the maid rewound the gramophone.

'Come in,' we said. Noel sat in an armchair and looked in amazement.

'So that was what was so heavy, a complete home in your luggage. Books, ornaments and bed covers, pens and paints. Now I understand.'

It was the first home he'd been in since leaving Australia. He took photographs of it before settling down to plan his next climbing expedition.

In the morning, Rosie and Noel, together with the two Italians we had met at Lima, left on a four-day climb through the mountains to Machupicchu, the great Inca citadel. And I sat drawing outside Alluya, the university café on the Plaza de Armas. When it rained or hailed, I moved inside the café and drank *maté de coca* made from teabags and apple pie. Two Indian women sold cigarettes and sweets beside me as I drew. We all sat on the kerbside and I felt pleased to be under their wing. Sometimes a dozen children crowded round, leaning on me. Recordings of Mozart and Beethoven wafted out on the draft from the café's open doors.

* * *

Cuzco is an extraordinary town. The view of balconies and yards, gardens and trees that can be glimpsed through the little door in the big brass-studded double doors of our *pensione* is of a typical sixteenth/seventeenth-century Spanish town. But Cuzco is squarely built on the foundations and walls of an Inca city that the Spaniards were unable to demolish. The great sloping dry stone walls are built of huge blocks of granite, cut and fitted together so exactly that even a thin blade wouldn't fit between the slabs. They have survived earthquakes, wars and neglect. Occasional trapezoid stone doorways, built with earthquakes in mind, can still be seen in the rows of oblong Spanish entrances.

After the sparkling white stone of Arequipa, it took time not to see the town's greeny pink and stormy grey rocks as gloomy. But gradually, as I began to enjoy Cuzco, I found it exciting to be in this variegated pink town.

On one wall rebuilt as a convent, a swarm of little serpents were carved, simply but with unsettling vitality; nearby was a limp Spanish heraldic dragon. A large Inca entrance, now a carpenter's shop, had a pair of very erect snakes greeting each other across the wide lintel.

The more I looked, the more I saw in this extraordinary and often terrible land.

There was little jungle baroque, mostly endless candied pillars hung about with Italianate bunches of grapes. The huge churches were dark. Coming in out of the brilliant light outside, all I could see at first were the thousands of candles lit to whatever saint was nearby, or outside whichever chapel had its huge golden carved gates open that morning. The iconoclastic altars were made from the gold ripped off the walls of the Inca temples and recast in designs of stunning vulgarity. They covered every chapel, nook and cranny, monstrous dressing tables to a Christ wearing a velvet and gem-studded waitress's outfit or to a Madonna in a similarly decorated ballgown.

But there was a sprinkling of heartfelt pictures hanging in the dark, painted by the heathen Indians with a strangely

magical combination of austerity and decoration – the Cuzco School.

Cripples and beggars sat hunched in tiers on the steps outside. Indian women sold candles, piles of grey incense sticks, and votives. From inside came the dull droning of sins being begged forgiveness and the pungent decaying smell of burning incense.

Down towards the Post Office, near a sixteenth-century church, stood the indestructible, gleaming walls of the Koricancha, an ancient temple of the sun. This was one of the temples whose granite walls had been hung with sheets of hammered gold before the conquistadors stripped them bare and recast the gold into the groaning altars of the Catholic faith.

The temple of Koricancha is thought to be a centrepoint for many other ancient places of worship. It was very austere and eerie; now stripped of ornament, its simple grandeur was impressive, undiminished by the houses built into the old walls. Dozens of paintings hung in the darkness of the building, only just visible in the half-light; strange sideways interpretations of biblical scenes.

Every afternoon it rained. It rained stair rods or hailed mothballs. Half the sky would be dark navy blue with edges gleaming silver where the sun shone out of the sky-blue sky and caught the underside frills of the clouds. Every afternoon there was a beautiful rainbow brilliant against the mountains.

It was morning when I walked up steep steps into the old town with narrow streets, carved doors, rickety balconies, glimpses of yards full of washing, constrained trees and gardens, through arches to a path cut out of the rock, then out into small farms and eucalyptus woods up to the first band of hills.

I met boys keeping an eye on flocks of sheep or llamas. Sometimes I heard the sound of pan pipes. Other sounds I

came across by surprise: in the silence I found a shepherd doing his homework deep inside a Sony Walkman. Out of his plugged ears seeped faint but familiar tunes from *Top of the Pops*.

After walking for more than two hours my lungs and head felt ready to explode, and the mountain still rose as high as before. But I had reached the ruined gardens of the Inca nobility, where most outcrops of rock were carved out with seats and caves and steps. There were crazy patchworks of rocks built into vast fortresses and now tumbling down the slopes into the grass. A smooth carved rock might have been a puma looking out over the river valley below.

Up again, winding through fields, the path ending at a strange low flat outcrop of rock with a small flight of random steps cut out of it. I threaded myself through a narrow entrance into the rock and down the narrow, meticulously cut tunnels which often sloped up to a thin slit of sky.

Winding about, deep and dark, I reached a wide altar. From numerous small niches were cut shallow channels which zig-zagged elaborately downwards, in the same way that irrigation canals twist about to slow down the rush of water. It came to me that sacrifices must have taken place here, the slow flow of blood criss-crossing the rocks in the darkness. I shot myself out onto a grassy bank and in the sunshine sat watching the goose pimples disappear from my arms and legs.

Beneath me were the pink pantiled roofs of Cuzco and, behind, the hills which continued undiminished. Beyond were the snow-capped peaks of the Andes. It was becoming really hot. The atmosphere was so thin that even exposing an ankle to the air for more than a few minutes could cause serious sunburn. I did a bad drawing and then cut straight down again to the main square of the town. With legs wobbling like jelly, a pounding heart and tight painful lungs, I made for the Café Alluya and drank coca tea, until the repeated playing of the scratched *Pathétique* drove me out again into the fresh breeze.

Lots of llamas were being led by women in white straw stovepipe hats with neat black bands. They had come from the

mountains, were heading through the square to the market. I joined their drift.

Saturday was the main market day. Bales of coarsely woven cloth and braid were piled everywhere among weeds and cheese and wire baskets of eggs. Babies slept or sat up in cardboard boxes. The pavements and roads were filled with stalls. Shops were still furnished with their early twentieth-century fittings – dark mahogany counters, walls of glass-fronted cabinets, drawers displaying goods indistinctly in the dim shadows.

The milliners had large mirrors of imperfect glass which distorted the little amount of reflected light, so that the height and shape of the white top hats constantly changed as the wearer ducked and peered at her greyed image. Indian women were mainly buying ribbon to refurbish their old, battered, but thickly banded toppers. Sewing machines powered by constantly rocking feet whirred away, illustrating skirts and petticoats, jackets and waistcoats with strips of pictures. Occasionally an old lady sat embroidering wonderfully intricate broderie anglaise with animals, birds, flowers, vases and hearts.

In a dark corner on a herb stall were dried bats and dried frogs. On the pavements were many bubbling cauldrons of thin glutinous grey soup out of which were ladled the cloven feet of sheep. Groups of people crouched on their haunches, sucking from tin plates. Children and adults alike fell asleep in the piles of handwoven cloth and hand-spun and knitted garments. The squatting beggars nodded off, their backs against the wall and the remains of their feet tucked underneath their bottoms, resting on bits of fur or newspapers.

And all around was a delicious variety of fruit and vegetables.

It had been pouring with rain, too wet to draw all afternoon. The pavements of the market were covered with sheets of

polythene and only waterproof and unperishable goods – piles of bits of pink plastic dolls, trays of second-hand false teeth and old spectacles – were still visible. The tall pyramids of aluminium pots and pans remained, but all the furniture, crudely carved with cherubs and scrolls and dates, had vanished. Rivers of water gushed over the cobbles. The water was up to my ankles in places; the beggars and cripples wrapped themselves up in plastic and crouched in doorways.

That evening I met some people on their way to the *pinà* – nightclub. The man on the door had fallen asleep, so we crept past and into an upstairs hall, where an Andean pipe band played.

Everyone was good-looking, well-dressed, a pleasure to see; certainly everyone had the regulation number of limbs and a whole face. There was a lot of laughing and dancing and friendliness. It seemed that most people had noticed me drawing.

7
MACHUPICCHU

t continued to rain torrentially all night, but by
dawn when I left for the station there were
patches of cold clear sky. It was Sunday, the
day of the excursion train. There was no
'Indian' train, no daily haul into the market.
Families were already gathering with their
picnic bags outside the station when I ar-
rived. We were all waiting to buy tickets to
see the ruins of the Inca citadel at Machupicchu.

An excessively tall, red-faced American found his re-
served seat next to mine and sat down. Under his good-
cowboy white hat he looked and sounded like a caricature of a
Texan oil prospector. He turned out to be just that, but lived
in a tent in the jungle with Peruvian Indian servants to cook
and wash and clean for him. He gave the impression he found
his life dull. Next to him sat a Canadian cyclist who was
anxious about his bike in Lima airport. His anxiety infected
me. I began to worry about my daughter.

The train climbed the side of the mountain backwards
and forwards like a shuttle, the guard leaping out to switch the
points at each change of direction. Women milked cows in the
meadows of the clean and neatly cropped alpine landscape;
the swollen pink river ran smoothly along valleys of willows
and broom hung with yellow tubular flowers. Men waded up
to their waists in the river water, swirling out vast fish nets;
smoke from the cottages curled up through flaps in the roofs.

But this was the Andes, not the Swiss Alps, and gradually
the scenery became exaggerated. The pink river foamed and
became seething rapids, the slopes of the mountains, rising to

59

nearly twenty thousand feet, were tipped up nearly to the vertical. The trees began to grow taller, with larger leaves and bigger and brighter flowers hanging from the branches. Passion flowers and flowering vines looped all over the trees from which grey vegetable beards dropped into the swift flowing water. Hundreds of pendulous birds' nests hung from the middle branches along with the Tillandsia rosettes, while higher up outrageous orchids were lined. My first sight of the jungle.

The train stopped quite often so the telephone engineers could test the lines that looped down and over the track with us. Everyone leaped out to breathe the air and see the view. Coloured ducks skimmed the rapids, big iridescent butterflies flitted from bush to bush in glowing sunshine; above us the white glaciers. White and golden church lilies and wild red gladioli grew in profusion, the oversized pink and red blossoms on the trees looking as if they were made of crêpe paper. Henri Rousseau land. It was magical.

Aerial ropeways and rope bridges crossed the Rio Urubamba. After several hours the train reached the Machupicchu stop and a bus continued the journey high up by hairpin bends to the ruined city.

It is an extraordinary place, built on two pinnacles with serried rows of immaculate terracing reaching impossibly up to the pointed peaks. The remains of the city still gave the feeling that repairs and a good sweep with a broom would make each little house habitable.

Sitting on a rock, drawing, was Rosie. She and her friends had arrived that morning in the thick mist of a nebulous and uncertain dawn, having walked through the jungle mountains for nearly sixty kilometres along the main Inca road. Now they were on their way down to find somewhere to stay in Aguas Calientes, a tiny settlement a few kilometres away. I would join them later. 'Ask for Gringo Bill's,' they told me.

The clouds were swirling up and down and around the mountain tops, so that the damp had become drizzle. It was humid. A stinking llama bit my foot as I sat drawing. He must have enjoyed my smell as I enjoyed his, for he soon moved

graciously on. The drizzle turned to rain, pleasantly warm and wet, driving the people away so that I had the ruins more or less to myself.

In the afternoon I set off along the steep subtropical track down the mountain to the river. I turned right and followed the narrow-gauge railway line one kilometre to the village, passing through two rocky tunnels, underneath the green plants and above the constantly roaring river rapids. Small slits of sky showed between the mountain tops.

Subtropical forest and rosettes of tillandsia

There must be an everlasting growing season, for the plants never seemed to stop, layer upon layer tangled and climbing, flowers and fruit weighing down the same branch and with pitcher plants and sprays of orchids in the canopy; like a firework display frozen at the moment between the 'Oohs' and the 'Aahs'.

The village of Aguas Calientes was a collection of

wooden shacks, built between huge mossy rocks on any surface that wasn't actually vertical. The cliffs shot straight up, forested green all around.

A small girl showed me 'Gringo Bill's', a half-finished building among banana leaves, giant rhubarb, feathery ferns and huge watery begonias. Several flights of old stone steps led up to it, curving between the plants which bounced as the big drops of rain hit their leaves.

There sat Rosie, Noel and two Italian men with the legendary Gringo Bill. For fifteen years this American had lived here, eight of them spent building this never to be finished hotel. I saw his dream of all those years ago. He now talked of building a boat – he could sail a new dream away from the moss- and algae-saturated nightmare that his life had become. Ten years ago he'd married a beautiful Indian girl and had two children. He radiated panic and imprisonment and isolation but was very welcoming. He loathed his mother in California.

In the pouring rain we walked up a track back into the mountains to the hot springs. In front of us the steam rose, meeting the descending clouds. Chickens were pecking the ground indiscriminately, some out of doors, others inside the shop, the bar or around the altar of the church, out of the wet. People waved and spoke in a friendly way as we trudged up to the two pools, one warm, one hot, and a gush from a pipe over a flat rock for a shower. The narrow river was the cold dip. Several Indian families sat happily in the warm pool passing their small children and babies around. Bigger boys and girls played in the hot bath.

It was wonderful. I swam around until like a lobster I was done to a turn. Feeling more relaxed, I realized that even though I'd enjoyed my days alone, there had been a nagging worry about the long walk over the mountain passes. A couple of months ago, four tough Germans were murdered in the same area. And nobody knew for certain who blew up the Sunday train earlier in the year.

That evening we sat and listened to a guitar and singing and talking, while Gringo Bill spoke venomously about Peru –

and his mother – to an unreceptive audience. He cheered up when the cocaine delivery arrived and was soon drifting happily on his dream of the sea and a half-finished boat.

Rosie thought I was unobservant and naive not to have guessed immediately what kept him locked in this utterly beautiful paradise of a prison.

It was full moon.

Before we left on the fruit and vegetable train for Cuzco, Gringo Bill sadly asked if I might not like to stay on. Or even return. 'You could paint,' and he swept his arms out in an arc.

At 8.30 a.m. the train drew up in the middle of the village. The track was the only road, it was the high street.

The train was overflowing with Indians who had already been sitting for three hours among, on and underneath bundles and baskets and boxes. We eased ourselves in and stuffed our bags in the small spaces still available.

Gradually we shook down. A continual procession of women sold food from big wicker baskets covered with cloths – fruit, cakes, tiny puddings wrapped in maize leaves, salad potatoes, cold drinks and coca tea. Men passed along the cluttered carriage hawking fizzy drinks, chocolates with unusually worn wrappers, and cigarettes.

When the ticket inspector appeared they all vanished; all those wide ladies wearing four to six skirts each and aprons simply disappeared until the official was out of sight.

A crate of chickens clucked and pecked at someone else's case of maize. The sack of pineapples tipped over when the train jolted. The view down the carriage was of spinning and knitting and repackaging fruit and nodding off, everyone leaning against the next person. Those on the edges leaned out of the windows or doors.

At every village more passengers and their goods clambered over and in.

The subtropical forest grew thinner and the grass shorter and springier. The variety of trees narrowed until even the willows were giving way to the government eucalyptus – in flower.

At noon breakfast gave way to lunch and roast suckling

pig was passed under our noses on its way to the teeth of our neighbours. Trays of unrecognizable cooked meat along with potatoes soaking up the juice sped up and down the train, rapidly becoming depleted. Dozens of baked guinea pigs were quickly eaten.

A family of musicians worked their way through the carriages, each concert just within earshot of the last and next. They rattled calabash and sang unfamiliar sad tunes with a peculiar Japanese quality, the melancholy sound echoing in their nasal cavities to the accompaniment of a guitar and a harmonica. The harmonica was wired to an amplifier carried by the father in a large hand-woven bag strung over his thin shoulders.

As the train trundled along, children stood by the track, lifting the hems of their skirts or the edges of their jumpers as if by this Mabel Lucy Attwell imitation money would be flung from the train. All I saw flying out of the open windows were guinea-pig bones, crisp pigs' ears, orange peel and banana skins.

It was one thirty when we arrived in the middle of the market at Cuzco. We had really enjoyed the journey and wondered why we'd never travelled second class on the Indian trains before. But we had been warned against such foolhardiness and we believed what we had been told about buffet and first class being more comfortable, safer and more suitable.

Now we'd follow our instincts and not the advice of others.

8
THE SACRED GARDEN OF THE INCAS

t was early in the breakfast coffee shop. Rosie had been sick all night so I sat alone with a prime view of four, large, many-tiered breakfast cakes, each more sickly looking than its neighbour. The sugar intake of people here was enormous, every flashing smile giving the solid gold proof. Even the poor and those without proper faces had their teeth framed in thin gold.

Many people suffered from a disease which from childhood consumed their features, leaving them with cobbled up expressionless scars as adults. Others must have lost their faces when they happened to be bent over the petrol primus at the moment of explosion.

Behind the house where we were staying I found a wide flight of stone steps that led straight up out of the town into the fields. The way became cobbled, then overgrown with springy grass. A stream joined it and ran down the centre as I followed this old road up into the eastern hills. Each side was still neatly walled and was wide enough not to be just a mule track.

This was the Sacred Garden of the Incas.

I passed by the Inca fortress Sacsayhuamen, its massive shiny stone ramparts set out in three layers of zig-zagging dog-tooth patterns, and on up to where white orchids flowered in the grass and cistus bushes grew everywhere. An infusion of cistus is taken to calm fear. I sensed that here fear was rampant.

After a few kilometres a boy shouted at me from a few fields away where he was digging. By his frantic arm waving it

65

appeared that the big Inca highway led somewhere he didn't want me to go. This was not Regent's Park, so I smiled, waved, and turned round to walk over another hill, remembering the stories of the cocaine kitchens, from where no outsider returns alive and the army leaves well alone.

All this fertile area had been the great country estate of the Inca nobility. Every outcrop of the white granite rock was carved with smooth steps and seats; every crevice and fissure enlarged and reshaped with more steps and seats, shelves and skylights, niches, balconies and doorways.

It was not as if a marble mountain had been thoroughly sculptured; it had all been hewn from white granite.

The eucalyptus woods smelt deliciously medicinal and fresh after the recent rain. Among the trees I met a young man with a catapult. I enquired the way to Salapunco – the caves of the Pumas. He led me through the wood to a grass road. Every few moments he darted off to retrieve items of his clothing or equipment which he had hung from various branches. By the time we reached the junction he was fully dressed and fit for the battlefield. He stood smiling and proud in his white plastic pith helmet and equipped with truncheon, pistol, submachine gun and two-way radio which was, at the moment he formally shook hands with me, broadcasting the frantic advertisements of the Cuzco local station. His original offensive weapon was hidden in his pocket. Pointing to a distant stone hemisphere he left me at the edge of his territory.

The only people in the landscape were a woman watching cows, two boys cleaning a skin in a stream, and a man struggling with a pair of oxen, ploughing. The only noise was the birds and a distant jet taking off from Cuzco's one-runway airport.

It had been a steady three hours' walk; I don't like the dark, but I was drawn to the Salapunco caves.

Narrow skylights let thin shafts of light into this maze of tunnels, lined with robbed and empty niches, all as smooth as silk to the touch. Deeper in I went, led by the grey shadows that showed the direction of the next filtered source of light.

Just when fear began to take me over, I emerged at the other side of the hill, blinking in the sunlight.

On the way back I climbed to the top of the cliff that overlooked the town. The hill was topped by three wooden crosses dressed in robes. Each had a sycophantic portrait of Christ nailed to its centre. Looking over and down the steep hillside, the tiles and courtyards of the town were clear. Behind all those closed massive timber doorways, through which I'd only managed to catch glimpses, were gardens and colonnades, tiers of archways, trees and flowers, fountains and washing.

Down the paths I quickly descended, through the gully of rubbish. I was soon in the lane that led to our room.

Rosie was not at all well; maybe she was having an essential rest from this land where the black side showed uppermost.

One beautiful and hot day with fleecy clouds bowling across the sky, Rosie and I caught a truck to a village in the next range of foothills, about one hour away. We were hauled up into the vehicle by our arms, along with sacks, babies, skirts, pigs, oil drums, chickens and smelly boys.

It was an exhilarating trip in the open air. The high sides of the lorry supported me well, under the armpit.

The mountains and fields were pink and green.

It was market day in the village and pottery was being laid out on the cobbles in the square under the branches of a huge tree. The big communal bread oven had just opened its doors and the smell flowed out and through the narrow street. We ate the wood-flavoured manilla-envelope bread hot. Bamboo poles stuck out of various doorways with red or white paper flags flapping. White indicated that the bread was ready to sell. Red showed where meat could be bought. Black pigs routed in the open drain down each street.

High up in the mountains, almost vertically above the

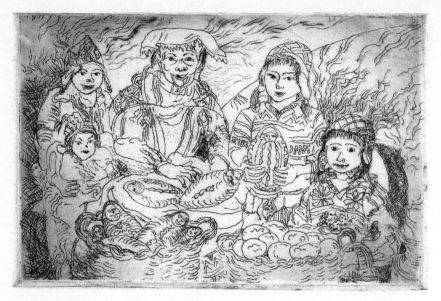

Family in the bakery in Pisac

village, were ranks of terraces cut into the contours of the steep hills. Above these was another silent, ruined Inca town.

Later we stood in the square and hailed a lorry to take us back to Cuzco. Gone were the days of protective first-class travel. This way felt safer.

The street out of Cuzco seemed to grow longer each time we plodded down to the Post Office, one of the few municipal buildings not built straight onto the foundations and walls of its Inca predecessor. Soon the walk would be worth a taxi ride. But that was before two letters arrived and we felt far less disconnected from our own world. Rosie and I sped back up the long Avenida Sol, through the Plaza de Armas to celebrate with a slice of cake – the same layered cream and chocolate sponge, leaning over under the weight of its soft brown icing, that I'd been scorning only a few days before. Instead of feeling sick, our headaches vanished.

There was an incessant café life in Cuzco. As each offered something different, we tended to go from one to another, taking a dish in each, then on to the Teatro Café for coffee.

There a Flamenco guitarist sang political and empassioned songs of injustice and fury. Finally we would have a nightcap in a very rustic bar serving beer or Pisco only, where wild musicians played like a relay race, a fresh player taking over without a pause to give the other a break. It was the most exciting Andean music I'd heard. Several series of bamboo pipes hung round the necks of the flute players, each in a different key. Tiny banjos – charangos – made from armadillo shells, guitars, chajchas – pairs of twisted llama hooves – and drums decorated with strange unSpanish patterns – all were played with a speed that blurred the fingers. And singing; amazing singing sounds and noises I hadn't imagined possible from any throat.

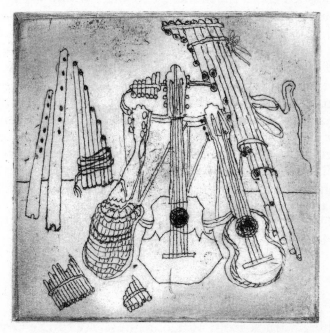

Musical instruments played in the Andes

Rosie had discovered nightclubs. I joined her one night in the 'Kami Kazi'. Three local bands played, one of which was a real treat. But the best surprise was a man who mimed stories

that made everyone laugh and cry at the same time, in a dance that was so slow that gravity appeared to be suspended. The lighting switchboard was worked by the young barman when he had a moment between pouring drinks.

Carts at the corners of most streets in Cuzco offered extraordinary mixtures of coloured spiced syrups, but the food was predictable and dull, a variety of potatoes rather than varied ways of cooking the tubers. Also rice. I thought a lot about salad and wondered where all the fresh food spilling off the stalls in the markets went.

Sunday was the winter solstice, the shortest day in the northern hemisphere, the longest day here. It is dark by 7 p.m.

There were signs of Christmas. Home-made paper chains were looped about the market; real and Taiwanese Christmas trees were for sale to the rich; the basket shop was packed up to the ceiling with Christmas candles joined by their wicks in pairs, especially embossed with strange pagan symbols, coloured and gilded. In the streets there was a big choice of Christmas cards. A nativity scene in orange flock showed a star guiding a string of llamas. Another in full colour opened with a pop-up Madonna standing above a close-cropped alpine meadow with children kneeling at her feet in glitter. Plaster crib scenes of all sizes appeared, and fairy lights. Even the blind street harpist joined the festive season with a barely recognizable 'Holy Night'. Pan pipes played snatches of Andean arrangements of 'Rudolf the Red . . .'

Christmas was certainly raising its familiar head, but not a single ingredient had its roots in any reality from these parts.

Catching a truck from near our house, we lurched over the pass to visit Chincheros – the word means rainbow in Quechua. The village was a couple of hours away in the mountains that overlooked the Sacred Garden; it was sited on a substantial framework of Inca remains.

The market had already spread itself out on a large flat

70

patch of grass that had been the courtyard of the huge defensive palace. High on the ramparts a large disintegrating church followed the exact lines of a partially wrecked temple. A full blood and thunder service sung in Quechua roared out from the open doors and over the market place. As I walked towards the church, the sound was accompanied by a chill and a heavy sweet stench of decay which poured out through the wide open doors.

Inside, the whole of the damp rotting plaster of the walls and ceiling was covered by untamed jungle – baroque frescos. It was as if Henri Rousseau had been given a new lease of life in exchange for selling himself to God. Where lumps of plaster had fallen away, the bamboo ceiling was just visible in the gloom.

Beyond the stunning patches of painting was the altar; a golden barley sugar fairground Wurlitzer. A young girl was changing a baby's nappy in the transept and everybody was singing with verve. An organ with emphysema wheezed out the tune and bells rang out, bronchitically cracked.

At the far end of the nave were two beds, placed centrally in line with the altar. Each was neatly made with worn woven blankets and finely embroidered white pillowcases and sheets which matched the church linen.

We walked up a cobbled side street and through a high elegant archway to enter the market. Beyond the people and wares spread out on the grass rose snow-capped mountain peaks.

Most of the women wore their everyday medieval clothes. Very few had shoes and all wore felt pie-crust hats. Some were piled with flowers for Christmas, while others were covered with small fringed cloths, resembling Edwardian occasional tables.

We picked our way into a tiny café. A table with various lengths of leg stood on the uneven earth floor. Two planks balanced on tins either side made up the benches where we sat for a cup of Camp coffee. It was more a chicken coop than a café, and after the initial shock of our intrusion the chicks re-emerged clucking.

Several women came in and bought confetti. A green parrot climbed all over us and strutted round the table screaming. A man sitting at the other end of the room offered to share his spaghetti with the furious bird who gripped the edge of the bowl in its claws and pecked greedily.

After the coffee was finished we walked down the lane, avoiding the pigs and piglets, and sat on the grass by the road near to a family of Indians who were also going to Cuzco. Soon we flagged down an open truck and all climbed in to join a dozen others standing up to their knees among bundles and sacks and livestock.

The next morning we braved a struggle with officialdom. Starting early, we collected together five kilos of thick clothes, surplus to the requirements of the jungle, and carried them to the customs office to send them to England.

The office was on the first floor of a once beautiful colonial palace. The decaying courtyard and ground floor were overrun with chickens that had miserably pecked each other's feathers. The naked birds squawked hysterically and flapped into the walls with panic as we walked through.

We had been warned that anything of value was unlikely to leave the office for its intended destination.

'Souvenirs?'

'No, winter clothing.'

'New?'

'No, old.' We smiled politely.

The official carefully printed 'Ten pieces of used clothing' on the form and looked at us seriously. It sounded un-attractive enough.

Once I'd sewn up the clothes with mothballs in a sack, we shook hands politely all round the dim office and departed down the stone stairs dappled with shadows from the courtyard.

Later someone remarked that it could be thought of as strange, even for the English, to send their laundry so far.

<p style="text-align:center">* * *</p>

In the midday heat I lay on the creaky mahogany bed in our beautiful room, the doors onto the balcony wide open. The ceiling was crazed with wide cracks that may have been the results of the last earthquake, in the 1950s. The chandelier appeared to hang at an angle above me because I wasn't lying directly underneath it.

A large black spider, bristling with hairs, clambered out of a hole in the plaster moulding and began to lower itself down. Down and down it ran along its own thread until it reached the palm of my hand. There its course was forcibly altered from an absolutely straight line and projected in a wide arc which propelled it through the open window. I continued to lie on the bed.

Rosie arranged an expedition comprising a young Peruvian Indian, a Swiss sculptress, a Swedish theatre director and a French clown. Together we left the town by the back way and walked up into the mountains.

Broad beans, potatoes and clover were flowering in tiny patches of fields. The irrigation channels rushed by us. Animals were grazing in meadows full of blue lupins and white orchids.

Through small farms we walked on and up the gentle incline. This was still the Incas' estate and everywhere were the smooth carved granite blocks of ancient interlocking stone walls. By a ruined house the rock had been hollowed out in a geometric pattern to enable heavy back loads to be supported and readjusted.

A man was weaving in his garden, one end of the warp tied to a tree and the other round his waist. He was leaning back, his heels dug into the ground to keep the tension as he flung the shuttle from one hand to the other through the warps, swaying from side to side with an easy rhythm.

Grouse flapped out of the grass sounding like football fans' rattles. Here and there were signs and signals; tufts of

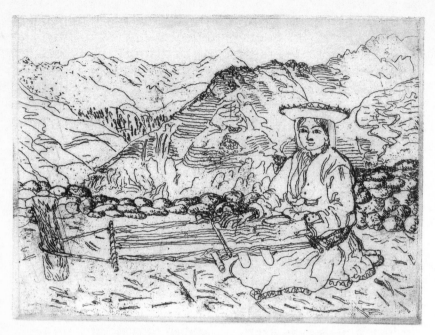

Woman weaving with backstrap loom

grass had been carefully knotted or plaited leaving messages.

After a few hours we reached a rocky pinnacle, and just a few feet from the top the Peruvian disappeared into a polished hole. It was just big enough for an adult to squeeze into. One by one we followed him, to emerge onto a balcony – the best box at the opera, overlooking a huge cavern of pink and blue striped rock. Other smaller balconies had been carved and all provided spectacular views of a waterfall and stream that flowed through the cave hundreds of feet below.

Now only the remains of the dam that had made the pool of this temple to water survived.

Climbing out and round and down we came to the clear stream and sat at the entrance on a large flat rock overhung with ferns and liverworts. It was dim and cool.

The French clown wore trousers that flapped about his thin legs. Not so much traditionally baggy, he explained, more that Peru had had the same effect on him as the sun on a

snowman. He put his hands in the pockets, pulled out a small bag and, with the sleight of hand expected of his profession, produced enough food for all. Lunch was delicious. Then meticulously wiping his hands on his baggy shirt, snapping shut and returning the Swiss army knife to the Swiss sculptress, we shared out all the rubbish and paddled into the darkness along the bed of the stream. This flowed on through a low narrow passage until, bent nearly double, we came out into the sunshine and a well-cared for garden at the bottom of a narrow ravine. The cliffs towered above us.

Up the cliffs and on in the heat over more hills we followed behind the Peruvian who leaped excitedly across the rocks, calling out our names in a song of encouragement. I could hardly breathe as the bottoms of my lungs were brought painfully into action.

Even higher, people were working in the fields and terraces.

Looking out from the Temple of the Moon

By mid-afternoon we reached a rocky outcrop on a hill. The real mountains kept their distance, looking even higher from this level.

We had reached the Temple of the Moon, a complicated labyrinth of hewn tunnels, all the seats, shelves and light-shafts to catch the moonbeams which had lit up idols, now long disappeared from their niches. The temple was a calendar.

Down through the shafts we eased ourselves and after creeping and crawling through the tunnels and passages eventually worked our bodies out of a steep fissure and onto the top of the temple. We sat and overlooked the whole of the Inca's Sacred Garden, the fortress of Sacsayhuamen and Cuzco faded pink far below.

Out of another trouser pocket the French clown produced a small but delicious high tea for everyone.

9
CHRISTMAS

Cuzco was filling up with people for Christmas. Foreigners from the mountains, rivers, jungle and desert were arriving, Spanish Peruvians visiting their friends and relatives. And whole Indian families from the countryside were beginning to set up camp around the edges of the main square, together with their livestock and large hay nets filled with ceramic ornaments for the Christmas Eve fair. The llamas gradually ate this packing. Clowns were attracting large circular crowds. Flutes played *La Traviata*, 'Rudolf the Red-nosed . . .', all arranged to run smoothly into the usual mountain sounds and tunes.

I had to push my way into the crowded telephone exchange to book a call home. The foyer was thick with sinister military guards, guns held at the horizontal. Sullen telephone officials hung around the main walls in an apathetic, bored way, and in the central kiosk, like puddings, were the fat ladies, powerful behind the bullet-proof glass and the distorting loudhailing system. The concrete hall was charged with the nervous tension of a hundred people waiting and waiting for their number to be called. I listened for three hours until all the announcements seemed to sound like my name and my body ached with readiness to jump up.

Then in the hubbub my name was called and we rushed to the cubbyhole in the wall. 'Hello, hello, we're well, yes, hello. Merry Christmas' and then the three minutes were up and we left the thronging exchange and the milling people. As I walked up to the square I felt the full feeling of Christmas

77

desolation; I'd hoped it would not turn up with me in South America.

That night Rosie crept up the creaking stairs at two thirty in the morning, excited and tired from talking and dancing with her friends. Soon after this, the singing of the homebound drunks subsided and the early-morning firecrackers started. The guards from the barracks next door huddled under blankets listening to Cuzco Radio as Christmas Eve dawned and the rising sun slowly lit up the diamond-shaped granite slabs in the road.

Christmas Eve was the big day. The huge market was in full swing. It was impossible to drive a vehicle through any part of the town. The pall of incense fumes hung low.

At dusk the stalls were reassembled round the edge of the square to form tables, and the huge Christmas feast began. Paraffin lamps glowed rather than threw out light. Boys lit bonfires with the rubbish and set off fireworks. A huge Catherine wheel spun overhead. Everyone sat and ate and talked and pan pipes played.

At eleven thirty the enormous main doors of the cathedral were slowly swung open and the warm glow of the gold and silver interior shone out enticingly across the square. Everybody stood up and slowly moved towards the doors. I walked with the flow, only pausing to buy a candle at the steps before entering.

Inside, the candlelit paintings loomed out of the dark, saints and martyrs, nuns and priests, all solemn and pious. The Last Supper, a massive canvas, leaned out from the wall. All the guests were really enjoying the feast and there was Christ, not without a certain smugness, just about to carve a large guinea pig – its feet in the air and a similar grin on its face. The Cuzco School.

People queued up to have their plaster Christ-childs blessed near the farmyard crib.

The service gradually began, quietly subdued apart from three old men singing too far down the nave to synchronize with the bishop in his scarlet mitre, whose words were too croaky to distinguish Spanish from Quechua and who was too

tired to stand up without a wall to lean against. The building was packed. Where I stood, people had fallen asleep on the floor. Families piled up together in each other's arms, oblivious of the droning service, exhausted by the biggest market day in the year. And most a long way from home.

The show began to remind me of the Moscow underground. The set was as lavishly decorated. A lot of people patiently waiting for their train, but a lot more milling around trying to change platforms.

After about an hour, I began to feel sick and sway around. Gently pushing myself past the butt of a semi-recumbent soldier I slowly threaded myself out into the main square and breathed in the cool air that was less heavy with pungent incense fumes.

Rosie was in the attic room of the Kami Kazi Club and the dancing was in full flight. The band was playing, the panetton was blotting up the drink both on the tables and in stomachs.

'Mum,' she said in horror, 'go home, you look terrible.'

That was Wednesday night and I had only vague memories of groping my way to the lavatory day and night until it was Saturday. Then, blinking in the daylight, I stood

Indian in pre-Colombian ceremonial costume

for the first time in the street. Christmas was over, together with its works and pomps.

'Do sit down,' said Rosie and that was just about all I could do. Rosie had really enjoyed Christmas. The leader and pipe player of 'the most famous band in Peru' greeted her warmly in the street and she glowed despite the sleeping bags under the eyes.

After a couple of days I felt fit enough to go to the market to stock up with embroidery thread for the long journey ahead.

Passing a photographer's studio I remembered that a visa for Venezuela required a photo as well as a yellow-fever certificate. We went into the yard and up the steps into the studio. In the middle of the darkened room a large plate camera stood on the splayed legs of its tripod. At one side was an enamel basin supported on a wrought-iron washstand, half full of turgid water. A comb tangled with long black hairs balanced on its rim. Above this a mirror reflected a distorted image. I looked with dismay at my wan expression. Not the perfect day for a photograph, but I decided against making use of the washing and brush-up facilities.

Taking it in turns, we sat on the velvet piano stool that was placed in front of a pair of blue velvet curtains. Drawn across for passport snaps, it would be looped up for serious portraits, to reveal a powdery painting of a stately scene, to add nobility to the sitter. A tatty cardboard Doric column stood in the corner.

Looking into the camera, blinded by the glare of two lamps, we held our breaths for the few seconds the lens cap was removed to expose the glass plate. Then we groped our way down the stairs and out, picking our way through the chickens in the yard.

I went back at two o'clock for the results, but they weren't ready, so for half the price of a cup of tea I joined the queue for the next marionette show. The tiny travelling theatre had been assembled in the market. From the paintings of snarling lions, skeletons shaking with fear or laughter, bulls stamping, warriors waving swords that decorated the kiosk, it

promised to be a terrifying and hilarious performance. The lady selling the tickets peered out, cross and bored, from the squarely open mouth of a roaring plywood puma. (At the Post Office all airmail is posted through the sharp-toothed fixed roar of a bronze puma.)

The first half of the show brought wave after wave of laughter. Each scene was a skit of a different sort of musician, with chamber music being reduced to Andean folk, and electrified pop properly demolished. But the act that made the audience really hold their sides and their shopping roll across the floor was the Paganiniesque performance of the miniature street harpist who finally collapses in the gutter while thieves run off with his money.

Blind harpist in Cuzco

After the interval, when we all sat fidgeting on the high benches, came the bullfight, which was very expertly played to the death of the bull. After a magnificent display of agony and

81

lifelessness, the victim bounced back on his four black woolly legs and took a bow while the audience screamed and clapped with delight.

All through the show, small boys managed to crawl under the striped canvas sides to catch a free glimpse before being flung out to rejoin the crowd of ragged children pushing and being pushed towards the entrance. Few had the money to go inside.

In the photographs we had a stunned 1920s look about us, our expressions wiped away by the glare of the lights. It was my untidy hair and not the exhausted pallor of my face that gave the date away.

Before we flew to Iquitos in north-east Peru, the first leg of our journey to Venezuela, I felt a low-grade nagging fear of general uncertainty. We had the whole breadth of South America to cross and I was becoming aware that I'd badly underestimated its vastness. Of course it was a perfectly good idea, but the thought of leaving our beautiful quiet room, this strange familiar town with its giant Inca walls with twenty-foot-high dados supporting the crumbling Spanish frivolity, made me anxious. I had become frightened of the unknown; self-inflicted unknown to boot.

10
THE JUNGLE

he Quechua women in their voluminous skirts and white top hats all disappeared with most of their livestock as the crowds of passengers were at last let through the glass doors onto the asphalt of the runway. For hours we had waited. Now, all the departing families had been kissed and hugged goodbye after their Christmas visits.

Only a few sacks of chickens and guinea pigs arrived in the aeroplane cabin as hand luggage. A pair of turkeys in cardboard boxes were stowed under the seats. Their heads and long necks extended from a hole cut in one side, while their fantails protruded from a slit in the opposite side.

The plane flew out of Cuzco along the thin valley, gaining height more or less with the mountains until at last we were above the white peaks.

We spent twenty minutes in Lima changing into a tiny aircraft. We raced across the tarmac and were catapulted onto the flight, four hours earlier than our booking, by an enthusiastic porter who had misread our tickets.

The aeroplane jumped about all over the place as we crossed back through the thermals over the Andes and out of the thick grey mist of Lima. Then the clouds opened up into huge white pillars and revealed the bright green jungle below us, intersected by brown tributaries of the Amazon. We flew low over forest fires and villages of huts. Sweet, urine-coloured Inca Kola flowed continuously and the air conditioning was turned up. The beads of sweat on our faces became streams and ran down our bodies.

Black vultures wheeled over the runway as we dropped out of the sky into Iquitos, where we unstuck ourselves from our seats and stood on the ground, soaking wet.

The Civil Guard were too preoccupied to greet us with the usual brandish of submachine guns. The immediate task absorbing the technical skills of four militiamen was to chase a huge slow stag beetle out of their office from where they said we could telephone and book a hotel room.

The hotel was new, very ugly, but clean and with running cold water at all times and a big fan which whirled the sluggish draft around the room.

At the back of the hotel ran the red-brown Amazon. Our room would have had a spectacular view of the river had windows been part of the design.

We walked towards the centre of the town. By the market, vultures were fighting over selected pieces of discarded flesh, ripping them apart with serrated beaks. Motorbikes balancing four or five passengers and slightly safer crowded family motor rickshaws whizzed about the streets, giving no hint of which side of the road it was usual to travel. Traffic circumscribed the everlasting games of football which were played in the sandy roads, taking precedence over all vehicles. Buses and cars had no windows.

Just on the edge of Iquitos, the shanty-town dwellings of Belen were crammed along the muddy banks of the Amazon. 'Venice' is the hopeful name of the main waterway into the palm-thatched shanty town. Soon the expected rain would arrive, the river would be in spate and the houseboats would rise to the level of the stilted dwellings.

We leaned on the broken but once elegant balustrade at the edge of the bank above the water and watched.

Many families occupied the tenements that had once been the rubber barons' extraordinary palaces. The façades of the buildings were covered with ornamental tiles. These had

84

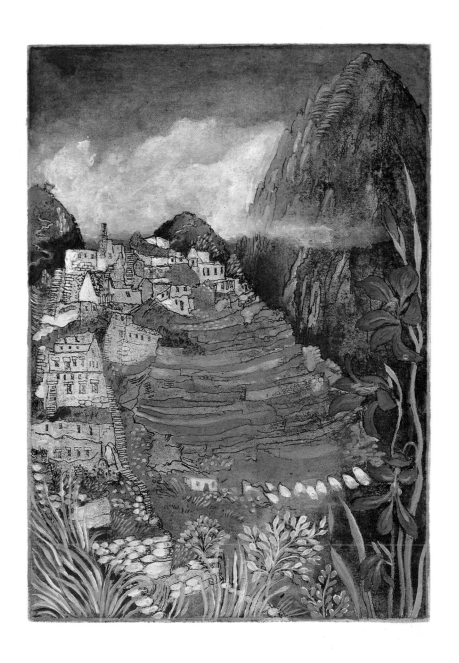

View of Machupicchu and wild gladioli

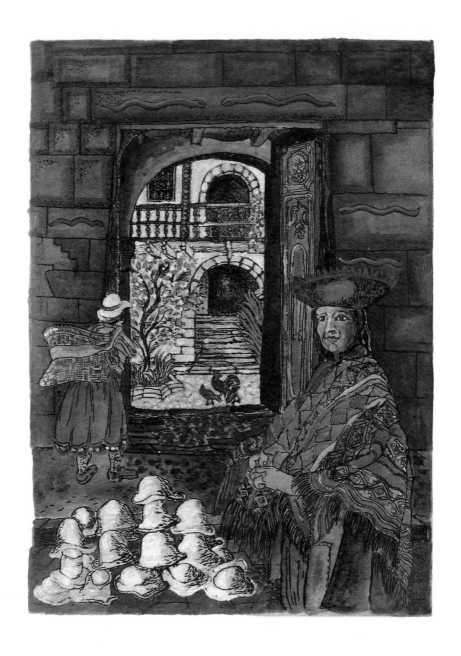

*Cuzco hatseller; a Spanish courtyard seen through the
trapezoid doorway in an Inca wall*

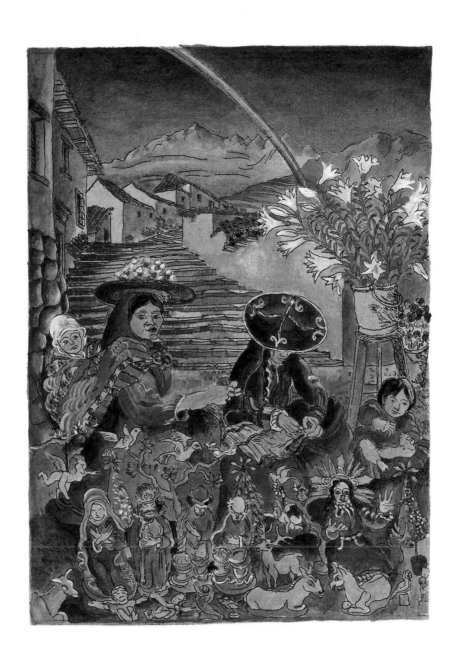

Christmas Market at Chinchero

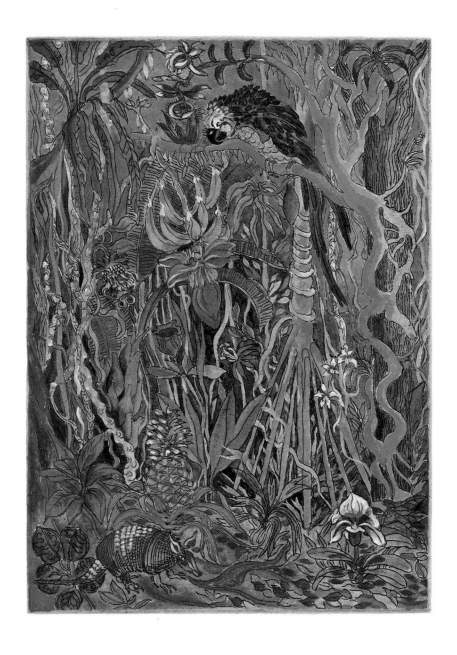

Inside the jungle with stilt tree roots, imaes, inflorescence of banana, military parrot and armadillo

filled the rubber-exporting ships when they returned from Italy and Spain. The vessels returning from England carried the cast-iron balconies.

In the Plaza de Armas an ornate cast-iron building designed by Eiffel had been brought from the Paris exhibition as a kit and bolted together here. This, together with the Rodin sculpture, Fitzcarraldo's mansion, a fountain that wouldn't have looked out of place in Rome, and a cricket club with a coat of arms embracing the date 1910, gave the place a sense of constant contradiction.

We walked along the promenade looking at the swirling flow of the river. Thatched boats carried passengers home to a big island on Belen. Dugout canoes were paddled around the floating houses and rotting boats.

The trees with large leathery leaves and the unlikely traveller's palms with their symmetrical fans stood around on grass with extra wide, bright green blades. Everything seemed to be exaggerated like a pantomime set.

Under a palm-tree roof we sat and drank lemonade while the sun set in a watery turquoise sky. Two yards of heavily armoured iguana, matching the sky, squatted motionless in a branch not ten feet from us. The cicadas began to drum incessantly and butterflies with incredible wing spans flapped around the bushes. Children were diving and playing in the water. There was the quiet hubbub of people enjoying the evening.

Walking back to the hotel, the pavements were almost entirely filled with rocking chairs. It was too hot to be indoors.

A small Christmas fair lit up one square. Some side streets were filled with boats, dragged up out of the way of the late floodwater. Through wide open doorways and large windows were Christmas trees decorated with twinkling fairy lights and traditional cotton-wool blobs for snow.

'There is nothing in this town,' the solitary man at the Tourist Office had said. 'You could go to the jungle – if you can find a guide. Nobody knows when the boats leave. It's a matter of waiting. A few days, a week . . . You could fly.'

Iguana and ferry on the Amazon

I felt endeared to this damp crumbling town that was built with the vision of rigid-minded fearless men at the end of the last century. When nobody could have imagined then that a few seedlings from their wild trees, nurtured at Kew Gardens and sent on to Malay, would bring the astonishing wealth of their rubber empire to fast decay and ruin.

For breakfast we followed the rare smell of real coffee and sat in a tiny greasy café packed with people from the market.

The vividly coloured television blared out an inappropriate lesson in French cooking. Outside, large women were preparing mysterious dishes over wood fires in the gutters and cutting vegetables and fruit with a terrifying swipe of a glinting machete.

A man at the next table leaned over and asked us in English how we had discovered the only place in the town that served decent coffee. And so we fell into conversation.

His name was Bruno and he'd come from Germany to manage a hotel camp in the jungle. It was two hours away on the Rio Itaya. His enthusiasm for the river and jungle fired us and within an hour we had left Iquitos and were travelling in an aluminium speedboat upstream, a rainbow arcing out from the stern. We passed a fine rusty passenger steamer, beached and rotting; a Willie Herzog hulk.

After stopping for a fizzy drink at a little village on stilts with tall cockerels strutting around the regulation Department of Cleansing hog, we went on up into one of the smaller tributaries before arriving at a long, wooden, thatched hut – the hotel.

Black cowbirds left the haunches of the cattle, where they fed on parasites. Together with bright yellow-golden orioles, they swooped over the river, mimicking the hotel sounds. A large blue and yellow macaw sat on the balcony and screeched hello in between imitating the lavatory flushing. Two smaller green parrots laughed endlessly together in an absurdly infectious way. The high hotel roof was beautifully woven from palm leaves and the garden full of vines with yellow flowers.

An iridescent turquoise butterfly flitted by, six inches across its wings.

One of the parrots sat on Rosie's shoulder.

We pleasantly rattled around the empty hotel. The holiday season had ended; everyone was waiting for the torrential rain.

In the afternoon we joined three Indian boys and raced a pair of grey dolphins with the speedboat. They used machetes with the same casual confidence that I apply to a knife and fork. We plunged into the water's edge tangled with roots and vines and hacked our way into the darker swamps. The trees were encrusted with orchids and the gloom was flecked with brilliant butterflies. Untidy flocks of green parakeets flew noisily about the undergrowth.

That evening we swam in the river as the evening pro-

cession of canoes returned from the market in Iquitos. Dozens of paraffin lamps lit the dusk, the yellow flowers in the garden glowed and the sound of the jungle grew louder and louder and louder.

The dawn chorus woke me at five o'clock. Gradually the blue sky grew brighter as the early morning procession of canoes headed downstream towards the town. Each boat was loaded with bananas and family until the waterline was almost level with the top of the boats' sides and the people and their goods appeared to be sitting on the water's surface as they swept down the brown and silver river.

The mammoth turquoise butterflies were out in force. Vultures stood around on the hotel's football pitch, their great shaggy wings hanging out awkwardly to dry.

After breakfast we set off with Secundo, an Indian, for a walk into the jungle. A thousand shades of brilliant green flashed in the sun which filtered through the tree tops a hundred feet above. It was very hot, very humid, and wet underfoot. As we squelched through the rotting leaves, my boots caught in the overgrown roots and my clothes on the vines which swung about like twisting anacondas. Marmosets quarrelled in the canopy.

Secundo slashed the way nonchalantly through the vegetation that had regrown since the last people, quite recently, had walked along the track.

Motorways of ants passed by and up half-rotten tree trunks. A snake, fierce with orange, black and white bands, was sliced neatly in two by the single decisive swing of the machete. Another slithered off into the black dense undergrowth. Secundo hid the wound of the bigger half under some wet leaves – 'For the next person who comes this way – a joke.' It was a deadly coral snake.

We walked up hills and across streams, balancing along fallen trunks. Vivid butterflies and moths fluttered irregularly,

rococo centipedes cowered under logs, and tree frogs chir-ruped among the entwined passion flowers. The straight roots of hardwood trees showed above ground, frozen in everlasting press-ups out of the marshy spots.

There was constant and wonderful deception in the jungle. Harmless flowers and butterflies appeared in terrifying patterns and colours. Insects resembled sticks and twigs and leaves. Spurs on roots prevented predators from climbing up but not down. Moths with eyes on their wings hung from twigs to imitate the owl. Owls feigned death when mesmerized in the light of a torch and could be stroked. Birds imitated the calls of up to fifty other species. Fungus grew only on young saplings to repel hungry grubs and vanished when the tree was big enough to survive consumption.

We passed tidy farms and plantations of bananas, many different species, red and green and yellow. We saw yucca, the

Water filter imported from England, various parakeets, toucan and house cricket

roots of which we'd eaten for supper, and maize already growing among the slash-and-burn remains of a recently violently demolished forest. Past pineapple groves, we continued up. The smooth leaves of the plantains sounded like good quality cartridge paper as we plunged by. The dead leaves looked as if dozens of flashers had hung up their old tattered macs and scarpered naked into the forest.

We found miniature sweet wild bananas. Briefly we sat and ate these with a pineapple.

Strange brilliant scarlet flowers and huge quivering ferns hung over us as we walked. Fungi, lichens and leaves as large and intricately patterned as meat dishes were all around us. Purple legume flowers fell in clouds from high branches. Green and red parasitical plants clasped every trunk at every possible opportunity, their cups ready to catch the rain and slowly water their host plants by seepage. Everywhere was overcrowded with vegetation.

Our pace grew slower and the temperature rose.

Secundo stopped and showed us the narrow path of an armadillo, rare today with banjos so fashionable.

Big earthworks like growths on trunks were the laborious work of termite engineers. Their nests hung down with the vines whose dangling roots searched for the ground before planting themselves and growing back up even thicker.

Finally, soaked by sweat, exhausted and thirsty we stopped by a giant redwood tree. We were in the untouched virgin forest, dark and gloomy but amazingly beautiful. It smelt of rot. We sat on tree roots, narrow and six foot tall at the trunk. Looking up and up were the tiny spaces of the sky.

'Bruno said you wished to see primal forest,' said Secundo. He smiled slightly. Rosie gave me a terribly hostile look and we began to slither and stagger down and back.

In a banana grove we met a tiny wizened woman. Smiling toothlessly, she stripped the bark from a branch and twisted it into twine.

We passed by a village with the usual football game in progress on the pitch. Tidy open houses had been built round the perimeter. Most people were naked, although a few adults

wore skirts or shorts. The school was closed for the Christmas holiday. Just outside the village was a graveyard. Twelve recent graves each had a handmade cross of sticks. Nine were the tiny mounds of infants.

'They just die of fever,' said Secundo.

Rosie had been badly bitten by mosquitoes and was asleep in bed. It was a refreshing cool dusk and I sat on the verandah. Bruno chatted.

'You must have walked twenty miles today. It's about thirty-five degrees Celsius and eighty per cent humidity.'

I refilled my glass from the earthenware water filter for the tenth time that evening. When I remarked on the nine dead babies by the village, he answered with a certain passion.

'There's about forty-five per cent infant mortality. Nobody believes that you must boil the water before drinking it. Then they inject antibiotics for anything – even cold feet . . .' His voice fell away sadly. Bruno had fallen in love with the jungle and an Indian girl. He'd been married a year. There was a touch of Gringo Bill about his anger.

The lamps were being lit and the parrot had been given a glass of beer to dissuade him from continually turning on the tap of the water filter to quench his thirst.

After supper I sat in a canoe being quietly paddled up the river by Secundo under a bright and twinkling canopy of stars. We swiftly cut through their bouncing reflections. Glowworms shone from the pitch-black bushes, and frogs sounded like squeaking shoes in every different size. I listened to the owls and rats and cockroaches against the background of night-time jungle sounds made familiar by the universal film soundtrack; it even included faint but disconcerting drumbeats from a nearby village party.

* * *

91

The next morning we balanced ourselves in a leaky dugout canoe and while Rosie and I baled with teacups supplied by the dining room, Secundo paddled us through the roots and branches of the flooded forest. It was dark and eerie with reflections of the tangled plants making everything more confusing.

The smell of rotting vegetation escaped from the water every time the flat paddle made a hole in it. More butterflies and moths, more orchids and passion flowers. A huge long-haired rodent bared its sharp teeth before fleeing. A pair of blue toucans blundered about the bushes. Mimosa leaves snapped shut as we brushed by. Flowers smelt heavily perfumed as we passed near. It was quiet but for the sharp sound of slapping as we hit the insects that came to rest on our limbs.

Through the low gloomy growth, we slid out onto the river again, bouncing up and down in the wash of fast launches. Secundo caught a tiny catfish and an orange and grey piranha.

When we returned to the verandah, the military parrot was stalking around with my knickers dangling from its beak. I would have made no move to retrieve them, but they had become unique to me. Parrots smell really odd.

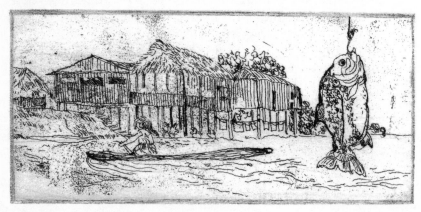

Village on the bank of the river, a child in a dug-out canoe and a piranha

During the afternoon, heavy tropical rain dropped like stair rods out of the black sky. Immediately we were engulfed in steam. I stood, holding a banana leaf over my head, and watched the tracks of the forest turn into hot turbulent rivulets.

11
DOWN THE AMAZON

he torrential rain had abated by teatime, and when we arrived back in Iquitos it had become fine steamy drizzle.

We climbed down a long rickety flight of steps, through a cat's cradle of mooring lines, across a dozen splintered planks that led us from one boat to the next until we came to the ship that was going to take us to Brazil.

The *Rio Amazonas* was an old British coaster. Its rivets were clearly defined in the early evening shadows. So were the numerous welded patches. But the uneven hull was smartly painted white. Having outlived its economical life around the European shores, it now sailed under a new name, a Peruvian flag, and carried its new cargo well.

It had been Bruno's suggestion that we join this ship; I had resisted.

'We'd prefer an ordinary ferry.'

'No, you wouldn't. Sleeping in a hammock with a hundred others so tightly packed that you can't turn in the night without landing in your neighbour's lap. And you'll get terrible diarrhoea.'

'It'll be too expensive.'

'Not necessarily.'

But I still harboured disappointment as we embarked.

Already aboard were a dozen elderly Americans, six matching pairs with smoothed and tucked wrinkles, youthfully coloured hair, and harsh, rasping voices. Also a family of Mormons, expounding unrealistic morality.

We fled from their imperious tones.

Everyone else had a beautifully appointed suite on the first deck, with large windows looking out on the constantly changing views, air conditioning, and bathrooms en suite. Bruno had arranged for us a special economy deal and our cabin was below decks among the crew's quarters. It was comfortable and homely and was kept cool by a continuous blast of air which roared through a hole in the ceiling. High up in the sloping wall of the hull, a little porthole opened out just above the water level. The showers were up a ladder.

We joined the other passengers on the open deck and sat in the canvas chairs around the perimeter of the dance floor, waiting. But still the *Rio Amazonas* stayed tied up. The passengers were hungry and listened reluctantly to the steward who padded out the hiatus with introductions to the crew, descriptions of the ship and the planned timetable. Hugo tried to placate his audience with friendliness.

'I am Hugo and this is Bédar.'

'If you see an insect on this boat,' Bédar said, 'don't, whatever you do, kill it. It could be rare and I would like to see it.'

All Hugo's good work had been undone.

As dusk fell, there was a general low-grade mumbling, whining and complaining. But still no supper. None would be served until we were underway.

Suddenly from out of the shadows a large bag landed on the deck, followed by a large man. Immediately, and with the commotion that more haste, less speed involves, the gang-planks were stowed, the ropes coiled, the gates locked and the engine vibrated into life. The *Rio Amazonas* put astern, backed out into midstream and pirouetted, now heading east.

The late passenger glared at the rest of us. He was a middle-aged Russian émigré from Manhattan who wore his wealth more casually than the other Americans but still expected it to ensure a smooth, uneventful journey from New York. He'd missed every connection and had only had a cheese sandwich to eat. This was Ivan.

The strings of lights that looped along the waterfront of

Iquitos grew quickly fainter in the mist as we chugged down-stream into the dark wet night. Out on the river there was an intermittent breeze and the New Year's Eve bunting flapped limply as it hung above the tiny dance floor.

Supper was at last served and the champagne flowed; it had an unpalatable sickly taste.

Two by two the New World travellers retired, until only Rosie and I were left, with the crew. Just before midnight the captain arrived and everyone hugged and kissed everyone else. Glasses were lifted up high into the humid air, and those whose sweet tooth allowed drank the toast in Peruvian bubbly. Happy New Year.

The deck had become quite crowded and we whirled about dancing as the hot rain blew in from the surrounding darkness.

'Goodnight. Happy New Year.'

'Goodnight.' And I left Rosie among an admiring crew.

I lay awake in the cabin. It was· like being inside a kettledrum as the boat hit and overtook huge trees that had been swept out of their jungle anchorage hundreds of miles upstream. In the middle of the night there was a vibrant crash that brought the boat to a shuddering halt. This was followed by the sound of a dozen footsteps running to the bows. The engine was silenced and gradually the other noises died down. Even the taperecorder no longer churned out its disco sounds over the water. It was wonderfully quiet; the party was over.

Rosie crept through the door.

'We hit an island. Only a soft one.'

The captain had decided to tie up to a nearby tree and turn in.

'Was anybody on the bridge?'

'We were all dancing,' whispered Rosie. And turned over in her bed.

<center>* * *</center>

The boat was well on its way again by the time I climbed up and out onto the deck. The sunrise was striped orange and the jungle was steaming. Only one other person was in sight – the late arrival, Ivan, leaning over the rail. He looked less furious and less formidable in the morning light.

We drank coffee and talked, waiting for breakfast. The sun rose higher in the sky.

'I don't think they'll ever forgive me for keeping them waiting.'

'They don't seem very effusive about me either.'

He laughed. 'May I join you for breakfast?'

By the time the mist had lifted, the *Rio Amazonas* had anchored, a little later than the scheduled dawn outing Bédar had promised us. We clambered into a launch that was tied beside the hull of the ship and travelled up a small channel into the forest.

A three-toed sloth hung high in the branches while along the tangled roots that trailed in the water a procession of leaf-cutting ants, each loaded with a bit of leaf, were hurrying up a vine. Kingfishers, golden orioles, blue-black anni birds darted about the trees and bushes. A ten-foot tree iguana, grey and aloof, remained immobile in a tree top even though we clapped and shouted. Cardinals flew above the water and a solitary hawk perched on the penultimate dead branch of a great ghostly tree.

Magnolias, camellias, morning glory; pods of every shape and size, pendulous nests of the pendular oriole; water buffalo up to their twitching ears in floating lilies; white and red orchids, white and red passion flowers – all were displayed against a background of vivid green leaves and the greys and browns of trunks and roots, straight and curly, that struggled out from the penumbra of the eerie mangrove swamps.

The annual rains were due, when the water level would rise ten feet or more up to the black tide marks on every trunk in this flooded forest.

We tied the small boat to a post in the bank, climbed up the slippery mud and along a well-kept track.

Bédar was born and brought up in the jungle; his eye was educated like a hawk's and he knew about the plants and animals. In his mid-twenties he married and moved to Iquitos. His passion remained the tropical rainforest.

Smoke drifted up through the trees into the mist and in a clearing we came across the large communal house of the Bora tribe, to which Bédar belonged. He had only visited their village once before and the introductions were of Edwardian formality.

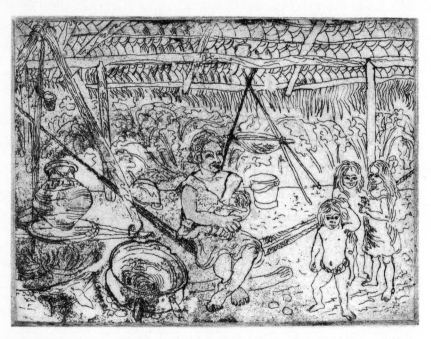

The communal hut in the village

Flat manioc bread was being cooked and a tiny shrivelled lady of eighty, curled up in a hammock rocking a newborn baby, filled her leathery cheeks with air and blew at a fire over which hung an earthenware pot. In the centre of the open room was a deep, wooden, tube-like mortar and a long smooth wooden pestle for grinding coca leaf into powder.

Baskets hung from the rafters and the brown children rushed around. Next year they would have their own school and teacher.

Water is poured through the ash from a certain tree. It drips out of a funnel made from leaves. It is the important salt supply. Combustible resin is collected to help start the fire. Eight families lived in the three or four stilted houses nearby. We sat on logs that formed a square in the house and talked. Bédar translated the language of the villagers into halting English. He explained that Ivan and I were not associated. They laughed. Everyone was extremely polite and smiled a lot because it was such a special and rare experience for all. They were as interested by descriptions of our way of life as we were fascinated by theirs. Only once before had foreigners been brought to visit the village.

As I squatted on the log and sweat poured down my face, a dignified woman gave me a fan she'd made from woven twigs and the black feathers of the anni bird. The head man invited us to join him on a walk through the woods. He carried round his waist a small string bag full of the coca leaves that would stave off hunger and give him the energy for a full few days' hunting.

When we left, everyone came out to wave us off.

The ship reached the first army post. It was really easy on a tourist boat, all the formalities were dealt with by the diminutive and always cheerful captain.

We travelled on. Blue and yellow macaws screeched and zoomed overhead, always in twos; storks stood on the riverbank, still and thin as the white trees that grew near them. Pink dolphins swam and dived in synchronized pairs. The sun shone all day and still everything remained damp.

The Americans were admirable in an infuriating way. They loved this trip too; they said so hourly and with enthusiasm. They struggled around in the heat, hung about with

every sort of camera and microphone. The wives were not altogether friendly to Rosie and me, nor to Ivan either. But the husbands thought we were quaint and as daring as Livingstone. Each tried to have a little private chat with us now and again, to make sure they'd hate to know us better.

One morning the ship drove its nose into the bank and was tied up to a tree.

The six pairs of Americans went fishing. We dived into the water among the dolphins who played near us, churning chilled currents of water up from the bottom. We swam to a small lake where the victoria lilies grew among their pads, four foot in diameter with edges raised like tea trays.

On the afternoon of our last day aboard the *Rio Amazonas* the ship was tied as usual by a bowline to a tree. Most of the crew and passengers sped off in small boats to a football match in a village upstream. The crew were to play and the passengers to cheer. The arrangements had been made through loudhailers from the ship's bridge and much shouting from the bank as we slowly passed.

Ivan and Rosie and I were left to swim in the green water where we were joined by the captain.

'You make too many drawing, take too many photographs. I can't imagine you have time to look,' Ivan said.

I bravely dived off the rails of the first deck.

'And keep your mouth shut,' he added, 'or you'll catch something dreadful.'

We sat in hammocks and rocked and talked until the sun began to sink and the white storks folded up their necks and flapped low over the water into the silhouettes of the trees. A spectacular dry electric storm lit up the sky with sheets of lightning and a new moon rose.

That evening we tied up by a village and went to the bar. We danced to the crackly sounds of a worn gramophone record.

'Mum,' said Rosie, 'do sit down.'

* * *

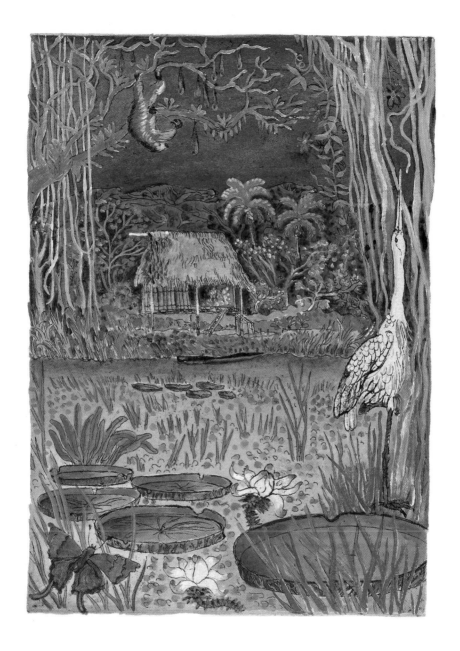

Victoria Amazonia lily growing in a backwater off the Amazon

*Teatro Amazonas; a painting by an Indian and a Venetian
glass chandelier*

Flamingos after Audubon and marine life in Chichiriviche

Sunset over Amazonian rainforest

Rosie and I took breakfast with Ivan. He was returning to Peru. We were travelling on. The customs man was having breakfast with the captain as we chugged along.

It was incredibly time-consuming and complicated to negotiate the corner where three jungles met on the borders of Peru, Colombia and Brazil. With the correct exit stamp from Peru, we arrived in Leticia, Colombia.

'The MV *Ituana* sails today,' said a runtish little man called Tarzan who was hanging around the Hotel Anaconda where we had dumped our baggage.

'Really?'

'Yes, yes, fifty dollars each, you'll be in Manaus by Tuesday.'

I showed him my Thomas Cook traveller's cheques. He was intrigued but shrugged his shoulders. The money exchange operated openly on the black market, but only in cash.

'I must go, my plane leaves in an hour,' said Ivan. He pressed some paper into my hand before blundering out through the glass doors of the foyer into a waiting taxi.

When he'd vanished, I opened my palm.

'Two hundred dollars!' said Rosie, shocked.

We sped round the market which led down through the rubbish to the rotting flotsam at the water's edge. Loo roll, Black Flag insect repellent, bread, fruit, cheese and two rainbow-coloured hammocks. With Tarzan we dashed to an aluminium speedboat and more or less flew the 36 kilometres to the Brazilian port of Benjamim Constant. There we discovered that the *Ituana* might leave in two days' time. Nobody we spoke to was sure.

Tarzan had vanished.

In a slow depressed procession, Rosie, me, and six small boys staggered up the rocky high street under our luggage to a dubious lodging house with a sand floor, a leaky roof and ragged mosquito netting in the windows. The air conditioning roared and rattled like an old lorry engine. We felt very nervous and gloomy, and we thought back with the rosy glow of hindsight to the time we had spent with the very rich.

'I expect they were all millionaires,' said Rosie.

'I expect so.' And I lay on the bed wondering if the cracks on the ceiling were as structural as they appeared.

The time passed so slowly, it hardly passed at all. And it rained.

Eventually the evening came and we picked our way through the debris of the main road down to the waterfront. We edged our way into a bar. Sitting on the dilapidated balcony that stuck out over the mud banks of the river, we were joined by the barman and two of his friends.

'We want to go to Manaus,' I explained.

We watched the quiet comings and goings of little crafts dimly lit in the dark. Men chatted and laughed and bought us drinks. We sipped the mineral water and traced patterns with our fingers in spilled beer on the wooden table.

Behind us a batch of guns had been passed across the bar, and fat rolls of dollar bills were being exchanged for small packages.

We kept on smiling. The barman introduced us to more of his business associates, and soon everyone was discussing our problem. It became clear that the *Ituana* would be sailing from Tabatinga, thirty kilometres upriver. It was due to leave in five days.

We were invited to watch the Sunday morning football match. They made arrangements to meet at ten the next morning and go to Peru, as they were playing away. We looked out at the dense dark jungle a few hundred yards across the river that divided the two countries.

'Have you an entry stamp for Brazil?'

'No.'

'Ah.' They all agreed that we must go to Tabatinga and get a visa. They described how to find the border post.

'Or you'll be sent back from Manaus.'

Wearily we made our way back to our room past the women sitting brazen and tawdry in dimly lit doorways. They looked weary too.

The air conditioning was too noisy to keep switched on all night. Waking up in the grey, still, stinking heat before dawn, I felt very agitated.

Benjamim Constant was utterly squalid. Conveniently tucked away downriver, with no bank, no police, no border post and no customs officials, it was the hub of the local export and import trade. I recalled the kind, helpful men in the bar the evening before. Real gentlemen, real professionals; we were sad to miss the drug traffickers international away match.

We caught the first ferry going to Colombia. To our surprise Tarzan sat among the other passengers, too plump for his tight trousers, his down-at-heel winkle-pickers curling up at the toes and caked in mud. He showed obvious signs of a bad hangover. I supposed he could hardly be expected to go whoring on his mother's doorstep.

'There is no boat for five days. We need our passports stamped.'

Tarzan failed to feign surprise. 'I need a Coke, I have no money left.'

Crossly I bought the dehydrated conman a drink. For two hours the wooden ferry chugged upstream, picking up people from thatched huts on stilts built among the tall green rushes and reeds of the riverbanks. The boat tied up on the muddy shores of Leticia. Tarzan grudgingly helped us carry our bags.

We found a room at the Hotel Leticia, which was run by a kind woman who sat in her haberdashery shop next door. Our room was quiet and cool, and beautifully made entirely from different coloured hardwoods.

We left the arrangements for leaving this terrible confluence of countries until the morning.

12
MANAUS

ystematically we acquired the correct rubber stamps – exit from Peru, entry into and departure from Colombia – and by the time we caught the *collectivo*, the mini-bus that jolts between Colombia and Brazil, we felt quite legal. We were heading for the Brazilian airport at Tabatinga where, we had been reassured, the police would give us an entry permit into Brazil.

Our luggage was weighed in with nobody mentioning excess weight. To pass the time we read the small print on our tickets. Taba Airlines reserved the right to disregard the International Conventions on domestic flights.

The police office remained unattended. They were not expected to issue stamps from here today. While two people argued about whether it was Tuesday or Wednesday, we learned that Brazil is one hour ahead of Colombia. We were advised to return to the border post, four kilometres away down the rutted road.

Ten minutes to the advertised take-off.

The taxi lurched through the deep orange ruts of the road. At the border post the Chief of Police dangled a baby on his knee while a clerk turned over and scrutinized with great care several sections of the thick ledger holding the names of undesirables. His finger slowly ran down the columns. At last our passports were returned, complete with visas, and we dashed out to the taxi. It bucked erratically on ever-decreasing cylinders until it finally stopped. The birds chirped above the silence; steam rose from the engine.

We reached Tabatinga airport by bus. Sweat pouring, our hearts beating until it hurt, our legs shaking and unsteady, we ran into the airport building.

The flight to Manaus was running four hours late.

It was afternoon by the time we soared into the air. We made fans from paper and, along with every other passenger, vigorously flapped the air in front of our faces trying to create the draught that functional air conditioning should have provided. The windows steamed up like a bathroom and so did the camera lens.

Wiping the streams of water from the big oval porthole of the antiquated aircraft, I could see the jungle and rivers below. They were near enough to define the leaves of the trees and the sluggish flow of the water. The dead arms of the tributaries, amputated by silt, were black. Those that were flowing towards the Amazon were as orange as the road to Tabatinga. A circular rainbow whirled round the tip of the propeller and the clouds flew past at eye level. Occasionally a small village came into view below, with goats grazing on the viridian football pitch.

Over one of these, the aircraft's nose tipped towards the ground, the wheels clunked out from the undercarriage and we bounced over the tree tops and down onto the jungle-enfringed tarmac strip of Carauari. Its entire population had turned out to see the weekly flight arrive. The river was the village's only other link to anywhere else.

We joined the rest of the passengers in the neat aircraft-shaped shadow on the runway and waited. The luggage was moved to one side to accommodate a man on a stretcher who had a bloody stab wound in his stomach. While we waited, the first mate reckoned up the quantity of fuel being poured into the wings, his big fingers fumbling over the tiny keys of his pocket calculator.

When the aeroplane was refuelled, the Captain said that it was too hot to take off, and everybody slowly shuffled off the tarmac to the shack that doubled as the airport and bar. The stretcher bearers jogged off with their invalid into the shade of the nearby jungle. Only a few small boys were left,

swinging on the propellers. There was not a breath of moving air.

It was early evening before the temperature cooled enough for us all to load up. The groaning wounded man was laid carefully on the floor of the luggage racks behind the pilot. The mechanic reconnected all the oil pipes on the wheels that the children had dismantled by way of a game and the villagers hardly stood back from the welcome draught as the plane took a running jump and roared off into the sky with a shudder, heading east. A magnificent sunset followed us for nearly an hour, reflecting silver in thin scrolls of water visible in the dark green forest.

It had been dark for some hours when we finally landed, collected our bags and headed out towards a taxi and no known hotel.

It was late by the time we eventually found an unoccupied bed in what had formerly been a rubber baron's dream palace. Once it must have sparkled in ecclesiastical style with English cast iron, Spanish tiles and heavy carved doors. Now it had the same quality as a pile of wet newspapers. It stank. We were breathless with the smell of Jeyes Fluid overhanging a stench of decay. Big shutters opened onto an Ogee arch and a big tree outside.

Exhausted and dripping in the humidity, we lay on the dirty bed with our clothes on, the mosquito nets flapping open in the breeze of the fan. In a haze of insect repellent we eventually slept and awoke surprised that the Black Flag hadn't dispatched us for good. It hadn't dispatched any of the bed's insects either; we were covered with red bites.

Scratching, we dashed up the road, diving through every hotel doorway until we came to the Hotel Roraima where the proprietor said he had a vacant room. He wore a T-shirt saying 'I survived a Jewish mother'.

The vacant room was more like a cell, so we sat at the communal table in the courtyard, along with the extended family. It was not clear where the family ended and the clients began. Most guests were single men who lived there per-manently. Quite often they sat in their rooms making things to

sell in the street – fur belts, straw hats decorated with artificial flowers, looped wire necklaces. They smiled as we passed by their open doors.

'Is it true the English don't wash under running water? They sit in a dirty bath?'

'Yes, I suppose you could say so.'

Two palm trees grew out of the cardinal-red polished concrete floor of the courtyard. A big family hammock was filled with children playing. When one child cried and screamed, the other five joined in and this set off all six parrots. Everyone started talking louder to be heard above the children and parrots, as well as the television which was turned up so all could hear it over the tape recorder's giant loudspeakers. One macaw cried like a newborn baby. The kitchen was out in the yard too and every room had a finch in an ornate wooden cage hanging outside.

Pairs of shrieking, talking parrots, parakeets and macaws investigated our skirts and petticoats, tearing at them with their curved beaks. Hens and tall thin cockerels stalked around the yard imperiously pecking at anything possibly nutritious.

So we sat for the day, enjoying the friendliness and safety of the place, taking cover in our green room when it rained, which it did frequently. The washing hung heavy and wet, unlikely to dry over the chicken coop.

Manaus is a large duty-free port, situated where the Amazon is eight kilometres wide. It had only in the last couple of years been connected to anywhere else by a road blasted through the Indians' jungle.

The Teatro Amazonas had just celebrated its ninetieth anniversary, but no shows were planned until the dry season. It was one of the most beautiful pantomime halls I had ever seen. The details were just a bit bigger and bolder and more exaggerated than their European counterparts. Venetian-

glass floral chandeliers hung in dozens from the gilt, mould-ing-encrusted ceiling; golden Corinthian pillars supported great overhead frescos. On the walls were paintings of classical heroes collecting substantial maidens from jungles, all hung around with bright-eyed boa constrictors and manic parrots. Scenes from Greek mythology misplaced in Amazonas.

Gilt mirrors reflected everything a dozen times: plaques to the great playwrights and composers – some entirely forgotten; velvet curtains; balconies with remarkable views over the river; marble staircases and bevelled glass; cast-iron botanical gardens; polished brass fittings. Only the striped hardwood floors, glazed with polishing, had not been brought in by boat, imported along with the opera singers and orchestras that performed there.

We left, looking up at the other huge ornate buildings nearby.

In places where the asphalt had lifted off the pavement, cobbles lay exposed like roots to catch your toe and tip you into the road. The polished streets and buckled pavements were seething with traffic and people. The noise was shattering. What little clothing was worn was so bright that it proved difficult to readjust the sight to the rotting stucco of the old buildings. Each tried to outdo the next with exuberant decorative grandeur: scrolls and pineapples and flowers and shells, nymphs, saints and heroines, elaborate ironwork and windows all soggy, the pastel washes recoloured by fungus and verdigris, the façades crumbling and split by neglect and subsidence. All was seen through tangled bunches of electricity and telephone cables which looped from one building to the next. What was not carved was rusticated or tiled. Monogrammed cartouches overhung the pediments. Every trick in the architectural accessory book was here.

The main square had an empty octagonal bandstand. Dolphins at each corner and lyres entwined with olive branches gave way to lamps and masques of comedy and tragedy and lilies. Thin pillars with floriate capitals supported a pagoda roof which was topped with a lamp, all made of cast

108

iron, as were the rustic log bridges that curved up to cross the stream full of tropical fish. Fountains played and added to the wet in the air. In between the waving trees, lithe bronze statues of Greek gods oozed sexuality in the coy, falsely modest way that the nineteenth century loved: Eros on a metal puff of wind; Diana scantily decked out in iron fore-locks of fur.

In among all this, the Brazilians carried on buying and selling everything to hand while loudspeakers blared out the local music, no longer thin reedy pan pipe sounds drifting across on the air, but the heavy-duty vibrations of the Carib-bean bass. Like the heat and humidity, there was no let-up in the incessant noise.

In the cell-like room, with the fan on full, I lay damply on my back on the bed and gazed at the hand-printed roll-on flowery patterns in white all over the dark turquoise walls, sweating it out in central Brazil, waiting five days for a seat on a bus to a more remote place.

The sky was as heavy as lead, regularly belting us with rain like shot; over the port and the market it was even darker and made more threatening by wave after wave of vultures gliding

Vultures and clouds of flies on the roof of the covered market

in circles overhead. The grazed roofs of the nineteenth-century market were thick with perched birds waiting for air space to flap their wings into the sky or ground space to snatch and tear at the refuse. Silhouetted against the sky, it was difficult to pick out the birds from the cast-iron decoration.

Several pretty kiosks, closed years ago, stood abandoned, waist-high in drifts of rubbish decaying among the wooden shacks now selling food and drink.

The market halls, shipped in as assembly kits in the nineteenth century on return trips from England, were crystal palaces complete with stained glass domes that covered frenzied selling of meat, fish and vegetables from Carrara marble tables which stood on the swirling patterns of Italian floor tiles. A wide curved flight of marble steps led down towards the shore, growing blacker with slime before breaking off above the river. A retching stench rose from the debris that filled the gap between the bottom of the steps and the water.

Dozens of two-storeyed wooden passenger and cargo boats were tied by their noses to a narrow pontoon quay, lines of hammocks strung on their upper decks. The boats were painted with the care and style of a fairground. Three-dimensional lettering appeared to spring from each bow among the brightly painted fluttering flags and ribbons.

Manaus Docks

Goods were being loaded and unloaded by almost naked men; not a crane was in sight. Sweat poured in glistening streams down the hillocks of their muscled bodies as they carried huge sacks or boxes on the backs of their thick necks, balancing the loads with insinuating bodies and a touch from their up-stretched hands. At a jog they crossed from ship to lorry, picking their way through semi-floating timber, bricks, and flotsam sluggish on the oily water.

Only the painted lorries gave the lie to the nineteenth-century scene.

We went to the zoo. In Manaus it is a military installation on the outskirts of the town. The army had collected many animals from the jungle. The bus took us through the rubber barons' suburbs of semi-detached palaces to the modern high-rise slums and out to the jungle park.

After we were signed in, a young soldier with a machine-gun swinging from his shoulder marched with us to the gates of the gardens. He kept looking disdainfully over his shoulder at us as we panted along behind him in the sweltering heat.

We came across half a dozen soldiers standing around in battle dress peering up into the high trees. An ocelot had escaped. An anaesthetizing dart had done the trick and the furry creature was curled up in a Y of the branches, fast asleep. They were discussing whether to climb up.

We wandered on to see a boa constrictor almost imper-ceptibly sliding out of its skin as it continued its slow slither across a dead branch. There were lots of Henri Rousseau trees and tigers with sad eyes. We half expected to see a recumbent naked lady beckoning from a couch, but there was only the usual plethora of good-looking, scantily well-dressed women leaning their bodies here and there in a knowingly sexual way. And a lot of very peculiar creatures of South America.

Then we visited the cathedral, newly repainted down to the last blush on the cheeks of even the minor saints, inside

111

Letterbox and strange bird against a mural in Manaus

and out. The brilliance of the full colour gave the images a pantomime quality, all still, as if waiting for the show to start. Nuns stabbed their hearts with glistening silver-painted swords, and heavy crimson shone rich on their habits. There were pink plastic roses, clean as new pins, plaster lace, all white, and an enervated Jesus I wouldn't want my daughter to marry, his heavy eyelids half open over the rolling orbs. The rubber barons must have worshipped in the Teatro Amazonas.

The Christmas crib was still up, the half life-size farmyard scene complete with plaster snow.

13
THROUGH VENEZUELA

he party at the Hotel Roraima which had started at teatime on Friday was still gaining momentum when we left on our way to Caracas on Sunday night.

Great orange cockroaches had begun to amass in dozens. I'd spent the night before our departure disentangling them from my hair, while Rosie whacked others to death with a shoe as they climbed up the wall from behind the bed.

But we felt sad as we said goodbye. 'Recommend us to your friends,' they said.

At 10 p.m. the crowded bus pulled out of the bus station, passed the sad stone lions and left the stench of Manaus. It was 30°C on the town thermometer, all the windows were wide open, and by the time, we passed the first police check we'd begun to breathe again.

We sped into the dark jungle. Layers of white mist hung draped throughout the moonlit forest. Occasionally the monochrome night was punctuated by the warm yellow-orange glow of a paraffin lamp in a forest hut.

It was most beautiful.

The Brazilian Marco Polo bus lurched at speed over the Pan-American dirt track. The highway had been cut through Amazonia only two years ago.

At dawn we arrived at the river. The huge wooden bridge had been demolished by flooding and the great bulk of its remains lay scattered along the banks. As the sun rose in magnificent Walt Disney style, the army began to pump out a

113

pontoon sunk on the edge of the calm river. A wooden shack had already been nailed together and was selling breakfast – doughnuts and cooked fish, meat patties and Coca-Cola. Everybody levered themselves out of their seats and stretched their limbs.

The sun was bringing the full colour back to the forest by the time the empty bus was driven onto the newly floating platform and winched across the river by hand. Then it was the turn of the passengers, who'd washed and cleaned their teeth and peed by the water's edge in the meantime. The humorous young soldier operating the chain winch increased the speed of his winching as we came to land, and the pontoon crunched straight into the bank. Fifty people fell on their bottoms. Everyone laughed, wiped the mud off as best they could and lumbered up the slippery bank to the waiting bus.

Tortoise and iguana on opposite banks of the Rio Branco

Several soldiers joined us and then hopped off one kilometre up the road where a lorry had crashed, emptying its load. Scattered all over the roadway, for the most part their limbs waving slowly and hopelessly in the air, were hundreds of tortoises. Everyone got off the bus and most helped themselves to one or two of these edible creatures, stowing them under their seats. Then, waving to the soldiers, off we went.

Food huts appeared every two hours. More people clambered on at each stop. At one, a mechanic got out of the bus and overhauled the engine, filled it with oil, checked the tyres, and then gathered all the men to push-start the vehicle.

The jungle slowly changed to pasture, and mountains were visible in the distance, the first unflat, ungreen view we had seen since before Iquitos. Big black vultures, hunched and mean-looking, stood around like seedy barristers.

We crossed the Equator.

It was now winter and we continued sweating. Herds of cattle with elegant horns and humps like camels chewed the cud and stared. The mackerel sky thickened.

We crossed the Rio Branco by ferry, and clambered back on the bus which roared off leaving a six-foot iguana on the beach unperturbed, its head high, its immobility uninterrupted.

At 4 p.m. we arrived at Boa Vista, six hours early. We had been warned that the journey could take two days.

Boa Vista is a terrible, modern border town, still in Brazil, where the Venezuelan Consul lived. At 8 a.m. we would be at his door for our visas into Venezuela.

For eight hours we sweated it out at the Venezuelan Consulate; by 7 p.m. our passports were at last embellished with full-page decorative visas, completed by a signature that in a moderate country would have had the writer judged clinically insane. Then two hours at the hospital being tested for malaria and avoiding another yellow fever injection. Being women it was thought unnecessary to check us for syphilis. We felt very relieved at this piece of illogical reasoning; the results would have taken five days to come through, and nobody would change a traveller's cheque.

As the heat of the day abated I walked out of town to the Rio Branco, and there was the real Boa Vista – wooden houses on stilts with families swinging in hammocks on their verandahs deep in climbing plants, unpaved roads, lush gardens and bars, thousands of unripe green mangoes hanging in clusters from the avenues of trees. Steep tracks led down to the river where houseboats, fishing boats, gravel boats and canoes

115

were tied. Washing was drying all over the springy grass on the banks. Children were diving and swimming from pale, clean sandbanks off the shore. As I swam over to them, fishermen pointed out the deep places and strong currents. In the evening sunshine I sat on a gangplank and looked at the wild bank opposite with mountains beyond.

According to the television in the *pensione*, in England it was too cold for Big Ben to strike.

In the early morning we left the land of cockroaches and hammock hooks embedded in diagonally opposite corners of the rooms. Accompanied by a swarthy gold prospector who had come to town to buy an armful of panning sieves and some giant skewers for roasting whole beasts, and a six-foot-six German boy, gangly in shorts, we headed for the bus. Standing tickets only were available.

Cockroach and stag-beetle – actual size

For hours our insides were jumbled and jostled as we crossed the vast alluvial plain northwards. The road was raised above the wetlands where storks and herons and big hawks prodded and waded. A malibu shook its black goitre. Gradually we began to slow down and head upwards into the soft green hills, over numerous rivers and by waterfalls, fording the rushing streams on the flat pavement of rock bed.

Suddenly the bus lurched, but stayed miraculously on the strip of road and stopped drunkenly. A front tyre had blown. We all piled out to sit on the grass.

An eagle swooped and swirled on the air currents overhead while the replacement wheel was fixed by a dozen men.

Then up into the hills. By mid-afternoon we had reached the Brazilian frontier. All passports were stamped with exit visas and there were disorganized half-hearted spot checks on a few bits of smarter luggage. Every bag was caked in dust.

The tyre was repaired and the untidyly repacked bus lumbered twenty yards to a forest of limp flags and a piece of knotted string tied across the road to indicate the exact point where Brazil and Venezuela must have ceased fire. Here was the Agricultural Control and all the baggage was minutely and carefully searched. Coffee, beans, fruits, nuts, tea, olive oil were all confiscated and burnt. But we all shared the bananas and oranges before setting off for the military post, another hut embellished with coats of arms, dire warning notices and a long wooden table on the verandah. Passports were checked for the correct rubber stamps and all the luggage was once again opened and meticulously searched. All the seed pods I'd collected were thrown out by a young smirking guard. My dusty reflection looked submissively back at me from his mirror sunglasses. All our maps were inspected by his superior who, once he had been persuaded that they were for tourists, confidently pointed out our position somewhere south-west of Manaus.

Everything breakable the young soldier pretended to break by nearly crashing it down on the table. He laughed at the small collection of paperbacks. Everyone followed suit with false laughter and the customs officials clutched at their submachine guns.

At last everyone and everything was thrown back into the bus and in the now familiar cloud of dust we rolled the last few kilometres into Santa Elena.

It was just five to five when we braked sharply in front of the Federal Police Building. Everyone dashed in, passports

clasped on the end of outstretched arms. Three men stayed in the bus, bible-reading gloomy blacks from Brooklyn; they had to return to Boa Vista for a visa, ten hours back in the same bus.

In the office the television was showing Batman and Robin. Louisa in charge of the rubber stamp had gone shopping and the other officials shook their heads and suggested 8 a.m. in the morning. The bus going north left at 7 a.m.

Accompanied by the tall German boy, we headed for the Hotel Frontier, situated on the main square, in the centre of this little border town. Our bags were caked in red dust and the same red dust on our bodies had been turned into a paste with sweat. In the cooler evening air it was fast becoming a crust. We passed green trees in lush gardens; everywhere the plants were larger than life, and green mountains surrounded the town.

Still nobody would change our Thomas Cook cheques; we had no Venezuelan currency and no Brazilian left.

We signed into the hotel and sat in the beautiful central garden of palms and cool, dark deciduous trees. Little tables and chairs stood in groups on the damp grass.

We were introduced to a man who would take us to Ciudad Bolivar on the Rio Orinoco, a fourteen-hour trip over the mountain tracks in the night. But without entry stamps – no possibility. Someone knew Louisa so we drove around the town in search of her. Her mother said she would be up in the hills until 10 p.m. Egged on by the other six passengers in the jeep the driver drove back to the Hotel Frontier and unceremoniously threw us and our luggage out.

The German grudgingly lent us enough money to pay for the room off the beautiful garden and supper in the little hotel restaurant.

We were joined by a tired looking Dutchman whose parents had just arrived from The Hague – another lonely person who had decided to live here seven years ago. Alone he panned for gold and diamonds. His small farm was four hours away.

'Why are there so many roadblocks?' we asked.

He said that while there was anarchic lawlessness in Peru, in Venezuela there was a framework of order.

No, the bank wouldn't change traveller's cheques. The Dutchman clearly thought we were anachronistically quaint to have such faith in sterling.

The next morning at 8 a.m. Louisa was sitting in a pink frock at the Federal Police Station and stamped us in on a fifteen-day visa. A sullen lady.

A jeep followed us back to the hotel and invited us to Tururemo – eight hours away and $5 – 120 Bolivars. In the café a man offered me 100 Bolivars. Not enough. But we climbed into the jeep and drove up into the mountains on a bone-jarring road which had us twisting and shifting from one position to another in a fruitless effort to find a moment's ease.

We did not have enough money to eat when we stopped at the cafés and we drank the tap water; we were very thirsty. About every two hours we halted at a military post and our passports and luggage were thoroughly scrutinized.

We went up through the mist and then down the other side through woods until we began to see the extraordinary ribbon development shacks of the gold and diamond mining villages. They looked like a series of sets for a 1930s wild west film. Cowboys with herds of milling cattle swirled lassoes above their heads as they rode through the little towns.

The military police blocks here appeared every half-hour.

Petrol was 15p a gallon and the locals' huge cars were old and vastly flashy. At the petrol station two dark and very handsome men were leaning against a wall, twirling heavy six-shooters round their index fingers. They looked closely at our Thomas Cook traveller's cheques. No possibility, but the bank in Tururemo would change them before it closed at four thirty. The men decided to join us for the short trip to the next roadblock. Before they left us we had been asked if we might not like to stay with them in the village. But with no cash and our only means of support, the German boy, excluded from the invitation, we shook our heads, smiled and thanked them.

The handsome men were cheerful and friendly and waved us goodbye, their guns in massive leather holsters at

119

their hips. The driver put his foot down as if with relief and we sped towards the first section of asphalt road we'd seen since arriving in Arequipa. At twenty past four we rushed into the bank. No, no possibility. In fury the German boy slapped a $100 bill on the counter. The typist barely halted the flow of tapping. No, no possibility either.

We tried anywhere that anybody suggested might help, the jeep driver with his vested interest close on our heels. Eventually we arrived in procession at a tiny back street shop, thick with dust and nothing apparently for sale. The $100 bill was produced and grumpily the shopkeeper changed it quite fairly into Bolivars. The German boy was white, whether with rage or fear I wasn't sure. He told us we must return the money in dollars.

The man in the shop showed us his real stock. He brought out several faded and grubby soft plastic dishes; they were dishes of gold nuggets, graded in size from fishmeal granules to molten looking blobs of several ounces. No wonder the paper promises of cheques and banknotes had little credibility here.

A weak rainbow faded from the sky and a full moon rose from behind the clouds as we began the journey to Ciudad Bolivar. The bus was pulsating with the rhythms of continuous Caribbean music as we drove into the night. It must have been fatigue that drove us on; there was an irrational urgency to reach Caracas. The tap water drunk in the cafés was beginning to take effect and stomach cramps set in.

We flew to Caracas and found a modern hotel. It was everything I would usually find irksome, but it was wonderful: staff in uniform, smiling and obsequious; lifts; porters; rooms without individuality but with every comfort, including colour TV, iced water, hot showers, cleanliness, bedside lights, telephones. The restaurant on the top floor had a spectacular view over the city to the surrounding mountains. There was a roof garden, terrace and three-stroke swimming pool. The exchange thanked us profusely for our Thomas Cook cheques and even had a $100 note. The airline booked us a flight and the German boy found his friends; he now liked us.

We drank fresh orange juice at a shaded bar in the modern town centre and lapped up the atmosphere of prosperity and success that is part of the fabric of Caracas. And we watched the well-dressed good-looking Venezuelans and smiled as they smiled, with open faces.

14
CHICHIRIVICHE

We took the inevitable morning bus through the steep wooded mountains that hide Caracas, out through the numerous tunnels to the bare mountains and the flat green valley of Lago de Valencia and on past the coast of sea-gas works and ribbons of oil refineries. We were heading for the seaside.

At a bare junction to nowhere much we were turfed off the bus and pointed in the direction of the sea and the National Reservation of Wildlife.

We waved at the first passing vehicle and it bucked to a halt. Two cheerful Venezuelan men crammed us snugly into the tiny cabin of the articulated tanker and with a grinding propshaft slowly and graunchily headed towards Chichiriviche.

The slow speed was ideal and the drivers pointed out the white storks and egrets; spoonbills and thousands of flamingos reflecting the late afternoon sun; angular-winged black frigate birds sharply cutting through the air.

Vultures were busy re-sorting the town's rubbish dump. Further on we passed swamps thick with brilliantly scarlet ibis wading in the wetlands under the dark blue sky.

Our tanker was delivering water to a hotel, so it was in real style that we drew up and hissed to a halt at the reception desk. Here, just outside the cab of the water tanker, was the best place to stay, with everything we could possibly want and need. But when it becomes difficult to step out of the familiarity of a rusty cab to a new place, it's time to go home.

There it was – the Atlantic Ocean with huge breakers

rolling in and the evening wind full of the beach, sandblasting the village. It was the Caribbean coast, where coconut palms grow right along the silvery sand.

We sat by the flickering blue water of the swimming pool and talked. The wind blew wilder and brought sticky salt with it on the hot air of the night. We talked about our return to England.

In the morning we found a small fishing boat on its way to one of the nearby coral atolls. On its shores was a small church and a shed dispensing fish and drinks. It was harvest time for the coconut palms; we listened to the nuts crashing down to the ground as we swam in the clear green sea and laid ourselves carefully out on the white powdered coral sand.

Palm trees reflected in the Caribbean Sea

In under twenty minutes we reached our boredom threshold and abruptly ended our sunbathing careers. We hung our bags in a tree and walked round the island, which is really part of the thin coral rim of the lagoon. We picked up bleached white coral and wondered at the huge heavyweight Alice in Wonderland birds that were blundering around the sky.

In among the palms, a sleepy man craned his neck over the taut side of his hammock suspended between two palm trunks. He'd heard about our journey.

A rotund Frenchman showed us how to unhinge coco-

nuts from their trees by whipping them with one of their own leaves; how to crack them on the rocks to open them without spilling the milk.

Little lizards were everywhere.

On the north, ocean-facing side of the island were the coral beds. Wading out up to my waist I peered through the surface of the water in between the waves. There were amazing gardens of coral. Sea anemones, sea urchins and starfish, sea cucumbers among the branches, brain coral four feet in diameter, green and yellow, brown and pink, beautiful pale but vivid colours. Everything was rigid but appeared mobile as the waves made each glimpse wobble.

The Frenchman picked up a huge fan-shaped piece and handed it to me as if it were a bouquet of flowers. As I began to lug it across the island, Rosie said, 'You can't take that on the aeroplane.' So discreetly I hid it behind a rock.

We caught a boat and headed back towards the safe shade of the hotel balcony to read. Our travelling resources were very low. New places had become a great effort, seeing new things exhausting. And I should have felt well by then.

I hardly noticed the scarlet ibis gobbling mosquito larvae in a shallow puddle in the road.

Old ladies sat in wooden rocking chairs on the pavements; wicker chairs furnished every verandah. A flock of flamingos flew into the sunset and the black frigates darted and swooped over the fishing boats as we stepped over the nets being dried and mended on the sandy roads.

Nobody moved fast, football games were played in what appeared to be slow motion in the sea-damp heat.

We scuffed along in the dust from the little beach where the wooden boats were tied.

I looked ill. Rosie said my face was the colour of a fried duck's egg.

Between stomach cramps I swam in the swell. In the evenings I sat on a dyke by the wetlands and watched the scarlet ibis, golden orioles, flamingos and egrets. I looked at the beautiful sunsets over the distant mountains and watched as the palm trees became silhouettes when the light faded and

the water turned to a sheet of silver cut neatly into the dark landscape.

We caught the local bus to Puerto Cabello, two hours west. In a street full of nineteenth-century colonialized shacks we found the Bay Hotel. It too was a wooden hut with a stucco façade slapped against the front boarding.

We sat on the white sand and swam among yellow and black striped fishes in clear water near the dozens of pointed wooden fishing boats. The really big ships glided in and out between the harbour piers, hooting solemnly. Boys with buckets of oysters wandered among the families and groups of men sitting on the sand. Other boys ran more purposefully towards the big café, swinging gleaming tuna fish by the jaws.

The sun set over the oil refinery and the tankers at anchor gradually became black cardboard cutouts. We looked up and down for the armed robbers we had so often been warned against.

15
CARACAS

aracas was the most beautiful modern city I'd ever seen. Prejudiced against its concrete architecture and filled with fear by repeated tales of violence and crime, I liked the place on impact.

It had complicated arrangements of buildings, plants and trees, with sculpture inside and outside the huge glass windows giving panoramic views of the green mountains, blue sky and clouds beyond. Fountains were everywhere.

There was a mixture of shops and cafés, galleries and museums. I heard a concert in the University Park and saw a Picasso exhibition. A Miró and a Chagall hung on their own walls in the Museum of Modern Art. Henry Moore and Rodin were represented among the bushes and palms of the gardens.

Fruit juice was squashed before our eyes; it was the strawberry season. Ice-cream vendors rang bells to sell sundaes and knickerbocker glories and coffee that almost jerked us rigid. The sunshine was brilliant and the air at body temperature.

The parks were filled with people running, sleeping, sitting, walking. Rocket-nosed bras gave the women an unfair positive direction. And in the distance, over the constant dull roar of traffic, the surging roars of the crowds at the bullfight arena competed with the roars from the baseball ground.

Policemen casually wore bullet-proof waistcoats over short-sleeved vests. Huge 1950s cars with romantic names – Malibu, Fairlane, Oldsmobile, Waggoner, Chevrolet, Cadil-

*Travellers' Palm and Henry Moore in the
garden of the Museum of Modern Art,
Caracas*

lac – sat snarled up in the continuous traffic jams, hooting in
vain.

Red and black squirrels leaped weightlessly about the old
trees in the colonial centre where the eighteenth- and
nineteenth-century buildings gave us momentary snow
blindness with their new white paint.

Beggars had their regular pitches and most offered a
service – blood pressure readings, fortune-telling with the aid
of a canary or an almanac.

A man played his flute by a fountain, children carried
balloons and kites and little toys, and a crowd watched a
puppet show under a tree.

We walked round the edge of the Botanical Gardens back
to Sabana Grande and our last night in South America.

We met a man from Yorkshire. He'd just canoed from

Pucullpa to Belen, 4,500 miles down the Amazon. It had taken three months. His companion, he told us, had gone mad and continued paddling up the coast to Caracas. He was very jumpy.

That evening we stood on the roof of the hotel and watched the city grow dark and then become bright again with the artificial lights of slow-moving streams of traffic, grid-squares of windows in the towers of apartments, the rectangular lights of the municipal buildings, and the advertisements. Unrestricted and unrestrained giant bottles of aperitifs, car insurance firms, and the vast red M of Mac-Donalds – all the colours possible with electricity winked and shimmered in the heat.

A new moon rose upside down in the sky, like a neatly occupied hammock.

A NOTE ON THE AUTHOR

Corinna Sargood is an artist. She has worked on a large number
and variety of projects, including print-making, illustrating books,
film animation, puppet shows, children's theatre, converting
narrowboats, painting and etching. She lives on a barge in
London's Regent's Park.